RESEARCH INTO SHIVA: THE ENIGMA

ANCIENT PHILOSOPHY

INDIA • SINGAPORE • MALAYSIA

Notion Press

Old No. 38, New No. 6
McNichols Road, Chetpet
Chennai - 600 031

First Published by Notion Press 2019
Copyright © Ancient Philosophy 2019
All Rights Reserved.

ISBN 978-1-64587-716-5

This book has been published with all efforts taken to make the material error-free after the consent of the author. However, the author and the publisher do not assume and hereby disclaim any liability to any party for any loss, damage, or disruption caused by errors or omissions, whether such errors or omissions result from negligence, accident, or any other cause.

While every effort has been made to avoid any mistake or omission, this publication is being sold on the condition and understanding that neither the author nor the publishers or printers would be liable in any manner to any person by reason of any mistake or omission in this publication or for any action taken or omitted to be taken or advice rendered or accepted on the basis of this work. For any defect in printing or binding the publishers will be liable only to replace the defective copy by another copy of this work then available.

Vande Deva Umaa Pathim Suragurum, Vande Jagat Kaaranam

Vande Pannaga Bhooshanam Mrugadharam, Vande Pashoonam Pathim

Vande Soorya Shashanka Vahni Nayanam, Vande Mukunda Priyam

Vande Bhakta Jana Ashrayamcha Varadam, Vande Shiva Shankaram

Translation:

Regard the energy that is knowledgeable to be the master of tranquillity and the reason for the existence of the universe

Regard the enhanced pulsation that supports beings, the master of the living beings

Regard the direct and reflected light with guiding fire, that is near equilibrium

Regard the distributed protected living space, the uncertainty of Shiva

This book is dedicated to all those ancient intellectuals who had the acumen to see far and beyond and created works of literature such as the Vedas.

Further, this book is dedicated to all those ancient thinkers who could take those in-depth works of literature and reduce them to understandable, simpler Upanishads, that have stood the test of time.

It is also dedicated to all those thinkers across time who were able to understand and translate these works of literature into Sthotrams, Mantras and Ashtakams which contain condensed version of the core information and have retained their grain of truth from the original works, however much they have been distorted over time.

Without these works of literature, this book would not have been possible.

I salute all the thinkers across time who have perceived the information in these works of literature.

Table of Contents

Introduction	9
The Science of Truth	9
Mismatch in the Understanding of "God"	13
Why Shiva?	16
Why Sthotrams, Mantras, Upanishads?	17
Setting the Context	20
The Problem of the Observer	20
Limitations of Study with the Manas	21
Tatvamasi	23
Para Brahma Tattva	25
Deciphering the Environment	28
Awareness of the Environment	31
The Environment and the Knower of the Environment	*31*
Map of Knowing the Knowledge of the Environment	*35*
Timeless Environment	37
The Become and the Becoming	*40*
The Fuzzy Environment	*48*
Limiting Awareness of the Environment	50
Peeling the Layers of the Awareness	53
Untangling Awareness	55
Infinite Recursion	*62*
Equilibrium	*64*
Rationalization	*65*
Equilibrium, Change and Rationalization	*67*

Layers of Awareness	67
Manifestation of the Environment	75
Formation of the Environment	75
Connection of the Entanglement to the Environment	84
Relating Modern Science to Reality as Defined	88
Summarizing the Concepts of the Environment	91
Defining Space	92
Definitions of Direction	93
Forces and Inertia	93
Gravity and Centre of Gravity	94
Disclaimer	95
A Path into the Unmanifested	97
Searching for Clues	98
From the Unmanifested to the Manifested	101
The Science of Yielding	103
Distinguishing Between Isha, Rudra and Shiva	108

Introduction

THE SCIENCE OF TRUTH

All known translations and understanding of the Vedas, Upanishads, Sthotrams, Ashtakams, or Mantras, consider these works of literatures to be the philosophical concepts and ideas of Hinduism. Hinduism by itself is considered to be a religion. The sorry state of affairs is that these works of literatures are considered to be a spiritual and ideological belief system. But, I beg to differ here. Yes, I agree, that over a period of time Hinduism has taken the form of fanatical religion (more so now), and transformed itself into a belief system. In-fact I need to say, I cannot find "Hinduism" as a word, in these pieces of literature. It is definitely a word that has been coined over a period of time, in the very recent past, within the previous century, to attribute these works to some group or race of people. Hindus also is a coined word to represent a set of people from a certain region more specifically in India. Sure, there are references to Bharat or Bharatvarsh. Those are references to the land and the people of a land, nothing more. But, none of these works talk about God, people or religion. In-fact they don't even talk about beliefs. The problem is, no one anymore understands or knows the core principles and concepts that were originally propounded by these works of literature. Hence they have been classified and cast into superstitious works of philosophy.

To take a simple example: Not all people, in fact it would be correct to say that only a handful of people in the current world, truly understand quantum physics and its concepts. If, over thousands of years the number of people studying quantum physics declines to zero, what remains after that are only the words with their meanings open to misinterpretation. Photons, bosons, neutrinos, electrons etc., become just a belief system since we cannot "sense" any of these. Having lost the knowledge of proving the existence and studying them, what they mean, can only be transferred by word of mouth. These words themselves invoke no inherent meaning

within us. Any description written of these words is bound to be open to interpretation, as seen feasible. These are just acquired knowledge and unless transferred correctly can get lost in the sands of time.

Similarly, I believe, the concepts in the Vedas, Upanishads and other literature have been reduced to nothing or nonsensical in the sands of time. I agree, they do not talk about the same science as physics, quantum physics, chemistry and so on, but, science, indeed they are. Science need not always be the creation of what *we* call "technology" and "scientific knowledge." Technology need not always be that which enhances the luxury in human life. Technology is the practical use of "scientific knowledge" to enhance life. Life can be enhanced in many forms, not just with respect to comfort of matter. "Scientific knowledge" also need not always be that which understands the science of matter. In-fact matter is merely incidental in the whole scheme of things. Studying matter only helps us scratch the surface of the whole. Studying matter is like taking an equation for a simple harmonic motion, substituting specific values to 'x' and 't' and always staring at that one generated point and forming ideas around that point, instead of seeing the equation itself and seeing the variance based on the change in values of 'x' and 't'.

Veda or Vedantam means knowledge. Knowledge cannot be obtained from philosophical beliefs. The question we need to ask ourselves is "what is the knowledge they are talking about?" There is infinite knowledge. Knowledge is that which is known inherently. Knowledge is not that which we call *intelligence* of this human form! Philosophical beliefs, logical deductions by the brain and such can only lead to *intelligence* or "concluded knowledge." This happens only because, we as humans have limited access to that infinite knowledge. Hence we are always seeking for proof for this concluded intelligence. This makes us **intelligent beings** as opposed to **knowledgeable beings**.

I think the primary prerequisite to even start appreciating the science these works are talking about is the comprehension that *"reality" and "truth" are not the same*. Reality is what we sense, recognize and logically conclude with the brain, from the truth around us. The search for the truth is not philosophy or belief. It is a gradual diminishing of this staunch belief or conviction that there is nothing else other than this reality around us and to become aware of the unvarnished truth as opposed to a glazed version of the truth we call reality. This is "the science and knowledge" that these works are talking about. "The science of the truth."

It is very difficult to appreciate the nuances of such a science. The first and primary major setback with such a science is that we understand and accept ideas as facts through our brains. This means the brain itself is just a part of the reality and not the naked truth. Given that, what we want to study is "why these thoughts are formed and how these thoughts are formed," we inherently need to form the "correct thoughts" to understand them. How can we do this? It is as if one part of the brain is observing the other to understand! The "Kena Upanishad" brings this out succinctly when it says:

yanmanasā na manute yenāhurmano matam |
tadeva brahma tvaṃ viddhi nedaṃ yadidamupāsate ||6||

Translation:

That which the mind cannot think, but that which is the mind, know that to be the ultimate truth and not that which you have imagined.

Yes, the science of truth is pretty difficult to comprehend. Even defining what it is really studying is a huge challenge. Yet, while the path is indistinct and unclear, the end goal is well defined viz-a-viz "find the truth." The point to be appreciated here is, "Can we even feign to know when we have reached the end goal?" The words "find the truth" seems to have a meaning, yet, the knowledge itself is elusive without any means of knowing how to validate when we get there. It only has to be assumed that it is a knowledge that will be self-proven. It is for this reason that when describing any of these, the path taken is a path of negation rather than a description. For e.g., the Nirvana Shatakam by Shankaracharya says:

Na Me Mrtyur-Shangkaa Na Me Jaati-Bhedah
Pitaa Naiva Me Naiva Maataa Na Janmah |
Na Bandhur Na Mitram Gurur-Na-Iva Shissyam
Cid-Aananda-Ruupah Shivoham Shivoham ||5||

Translation:

I have neither death, nor fear, nor is there discriminations
I am neither father nor mother, nor do I have birth,
I am neither relative nor friend, nor teacher nor disciple,
I am awareness, the form of Shivam

> Aham Nirvikalpo Niraakaara-Ruupo
> Vibhu-Tvaacca Sarvatra Sarveindriyaannaam |
> Na Caa-Sanggatam Naiva Muktirna Meyah
> Cid-aananda-ruupah Shivoham Shivoham ||6||

Translation:

I am unimaginable, a form, without a form
I am present in all and I am in all senses
I am not attached yet there is no freedom from me
I am awareness, the form of Shivam

In Dasaloki, Shankaracharya says:

> Na chaikam thadanyath dweetheeyam kuthasyath,
> Na chaa kevalathwam na vaa kevalathwam,
> Na soonyam na chaa soonyamadvaidhakathwath,
> Kadam sarva vedhatham sidham braveemi

Translation:

I am neither one, for where is the second
I am also not alone nor also alone
Neither void nor also non-void
Yet, all learning in the vedantam is about me

In talking about the truth, it should be remembered that we cannot in any way use similar terminologies as we do in reality mostly because they make no sense in that environment. What does that environment mean? That directly leads us to the question "What does this environment of reality, really mean?" We have studied matter, we have called it The Big Bang, we have said immediately after The Big Bang this space around us was formed with gravity and hence time. We have studied in-depth to the level of photons, neutrinos and muons etc., particles to the quantum level, we have string theories and standing wave theories. Yet, we cannot describe what this "environment of reality" really is. This book is an attempt to understand what the ancient literature talks about as reality, the environment and the truth.

MISMATCH IN THE UNDERSTANDING OF "GOD"

In the modern day "God" is a term that is used for a wide range of understanding. Starting from the simplest opinion "A higher being that runs this world" to a physical form "a particle that forms and drives our actions in this world." But, what is to be noted in all these definitions is that, all definitions of God still stay *within the realm of reality* around us.

In its most common form, "God" is seen as an entity to which good and bad can be attributed. All that occurs, that is good and bad, that which cannot be explained or accepted by the normal human brain is attributed to fate designed by God. In this form of understanding, it is expected that the entity (God), perform miracles and is prayed to as a boon-granting being. While it is nice to have such a being, it should be remembered that good and bad, happy and sad, justice and injustice etc., are judgemental calls made by the human form. When the definitions of good and bad are not uniform within all human beings, why should any other being other than a human have the same platform of judgement as us?

For e.g., when seen from the angle of "climate change," "population explosion" and "resource deficiency," murderers are good and doctors are in-fact bad. The reasoning goes: it is because the doctors have extended the life expectancy to a very high level, we do not have natural causes of reduction in population, thus causing all the problems we are facing. In a more modern world acceptable example: Where murder is committed, by one person killing another, the action is considered wrong and punished, whereas, when an army kills a whole population using a bomb, the soldiers are felicitated as martyrs.

Every judgement requires a reference point. The society serves as the reference point of judgement for us. We have the definitions of good, bad, kind, miser, intelligent, clever, fool, insane etc., based on social norms. In such a society, a person tends to impose their ideologies onto the "God" form, and preach about kindness, compassion and any such emotions as "Godliness." Yet, these same emotions such as compassion stops at being shown to human beings who follow their social laws as opposed to being extended to everyone without barrier. In this case, the brain cheats us by forming a "feel good factor" for various reasons. One such instance is where, someone has listened to what we have said and accepted it. When this acceptance reaches a certain number of humans accepting it, it tends

to become a commonly accepted behaviour of any person in the society. This gives us the feeling of importance and thus we get cheated into believing that we have behaved according to the laws laid down by "God."

What Japji Sahib says in the following verses should be remembered through all this:

suni-ai siDh peer sur naath.
suni-ai Dharat Dhaval aakaas.
suni-ai deep lo-a paataal.
suni-ai pohi na sakai kaal.
naanak bhagtaa sadaa vigaas.
suni-ai dookh paap kaa naas. ||8||

suni-ai eesar barmaa ind.
suni-ai mukh saalaahan mand.
suni-ai jog jugat tan bhayd.
suni-ai saasat simrit vayd.
naanak bhagtaa sadaa vigaas.
suni-ai dookh paap kaa naas. ||9||

Translation:

Listen oh accomplished sages, the sky, the paatal, the ishwar, brahma, indra and everything, and all that which even time could not diminish, in all of you also is this "I" resplendent, listen those who try to destroy sadness and happiness, in you also is resplendent this "I"!!!

The point is, it does not matter how many living beings or humans respond to your thoughts and judgement, accept it and live by it. At the end even in all these living beings an "I" is present just the same "I" that is present in you. They and you, still live in the reality of this world around us, abiding by the underlying principles of nature more than laid down laws that needs to be consciously followed.

In another not so common form, "God" is considered to be that image within ourselves that indicates what we aspire to become. But, even in this form, the "I" is resplendent and all we are doing is aiming

to go into a higher plane of knowledge and not come down to the underlying truth that is driving the existence of this living being. In all these forms of "God" that we have envisioned, we have stayed in the current plane of reality and just traversed the infinite of **this** plane of existence. An explanation in the diagram below:

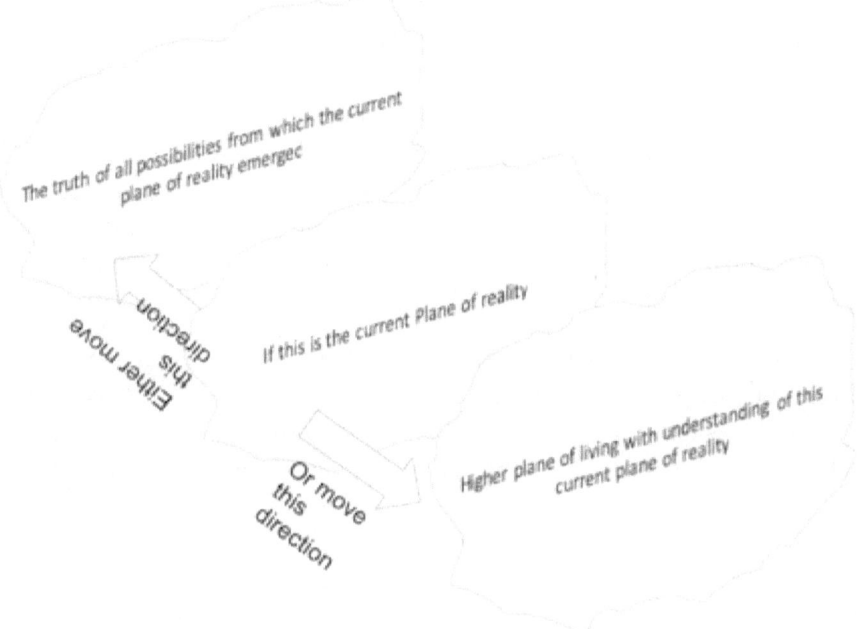

Figure 1: Direction of Movement of Knowledge

There can be multiple planes of manifestation between the truth and the current plane of reality. But, if, something triggered this plane of reality to form, imagining a "God" that extends this reality, can either retain us in this current plane within one of the infinite knowledge or just takes us to the next higher plane of understanding laid over the knowledge in this current plane. The direction of movement in such a case is opposite to the direction in which the truth lies.

From the various translations of the mantras and sthotrams, it looks like the ancient literature is trying to go down to the plane of truth and not go to other higher planes of knowledge.

This is the core mismatch we have in the understanding of "God" which has caused us to add unnecessary strict conditions and force ourselves into perceived goodness, kindness, service to poor and compassion rather than act on the natural impulses that we are born with.

Most of us in the current world, live rejecting the natural impulses, judging them as bad or trying to adopt another person's impulse as a threshold to achieve for ourselves. We live in a world where social judgements and impressions are more important than what we naturally are made to be. In such an environment, how is it possible for us to move from one plane of understanding to the next, to ensure that the ultimate goal of merging back into the unmanifested, happens? After all this is the cycle all of us are traversing. Irrespective of whether during the course of the cycle someone is good or bad, wins or loses, is miser or a donor, all of us traverse from the unmanifested become manifested and go back into being unmanifested without affecting the environment around us.

So, what "God," what "higher plane of living," what "lower plane of living," none of them matter. All that matters is that there is a truth where all possibilities exist with equal probability and ultimately we go back into just being a probability. Why not research, find and understand?

WHY SHIVA?

According to the various muddled versions of the various "Gods" that exist for the Hindus, "Shiva," "Vishnu" and "Brahma" are the three Mahadevas. If "devas" truly means "energies" (See the explanation of this in my Aitreya Upanishad translation at https://ancientinsight.online/2018/03/05/aitreya-upanishad-part-1/), then a "Mahadeva" must mean "prime energy." Further, the addled versions of the description of these "Mahadevas," lead us to conclude that "Shiva" is the destroyer, "Vishnu" is equilibrium and "Brahma" the creator.

If "I" is the observer, then, to begin understanding the truth, we need to study "that which is prior to the observer coming into effect." Now, if Vishnu establishes equilibrium, it means "Vishnu" is a concept that can come into effect only after "a whole lot of possibilities has already been chosen." It is concept that ensures, that those set of possibilities that form a more stable equilibrium is selected as opposed to those that are un-stable. "Brahma" creates. This can only come after an equilibrium of

chosen possibilities is established, to create something in that equilibrium. So, Vishnu and Brahma are concepts that retain us in the realm of this reality, as opposed to taking us back beyond this environment of reality into the realm of possibilities.

But, Shiva is different. "Shiva" is considered a destroyer. Destruction is not the same as "death." In Hindu philosophy death is just another state and the deva (energy) responsible for this state is "Yama" not "Shiva." Infact, there are stories where death is warded off because the person was praying to "Shiva" at his time of death. So, the questions arise: "What is being destroyed and from what, into what is it being destroyed?" If death still remains in the realm of reality, then the destruction that is talked about here should be distinctly different from the destruction that occurs within reality.

Here, then, we find, is one concept that potentially could form the link between that "unmanifested" from which this reality is formed and returns it back into that original unmanifested when the chosen possibility is destroyed. Both directions are "Shiva." When the unmanifested manifests into a chosen possibility and a chosen possibility is destroyed and returns back to the unmanifested.

Shiva has various names, "Isha," "Bhairava," "Shiva" and so on. Each and every one of these mean something completely different when seen in that unmanifested dimension and collapse into a single concept in the dimensions of this reality. In my view studying "Shiva" actually could mean the next step towards studying that "unmanifested environment or the environment of possibilities" that quantum physics talks about. Hence Shiva is the topic of this research.

WHY STHOTRAMS, MANTRAS, UPANISHADS?

There is a story that is passed down which is not popular, yet present in its rudimentary form. The story tells us about Vishnu, Brahma and Shiva arguing with each other "Who is the greatest?" with Brahma stating that "If I did not create, there is nothing to sustain or destroy, hence I am great," Vishnu stating "If I did not create equilibrium, creation is lost as soon as it is created" and Shiva stating "If I did not destroy, the cycle is not continued." Suddenly a Yaksha appears before them and places a feather in front of them and asks them to do what they want with it. Try as they

may, they are not able to do anything to that feather. The Yaksha turns into Brahman and states "If the Brahman is not present, creation, destruction or equilibrium does not even exist. There is no great or small. All are equally required."

What is important to note in the story is not about the greatness or divinity of any of the characters, but the fact that "the brahman" or "the truth" is considered to be distinctly different from "creation," "equilibrium" and "destruction." The next to consider is the Nasadiya Suktam from the Rigveda. The following a few verses from it:

> na asad āsīn nō sad āsīt tadānīṃ na āsīd rajō nō vyōmā aparō yat |
> kim āvarīvaḥ kuha kasya śarmann ambhaḥ kim āsīd
> gahanaṃ gabhīram ||1||
>
> na mṛtyur āsīd amṛtaṃ na tarhi na rātryā ahna āsīt prakētaḥ |
> ānīd avātaṃ svadhayā tad ēkaṃ tasmād dhānyan na paraḥ
> kiṃ chanāsa ||2||

Translation:

At that time, neither the unreal nor the truth existed. Neither the space nor ether existed. Beyond what and within what was born? Where and under whose protection was the power? How this existed is an inexplicable mystery. Neither death existed, nor immortality at that time, neither night nor day existed, nor it had appearance, breath untroubled inherent that one therefore that one none other like that beyond

> kō addhā vēda ka iha pra vōchat kuta ājātā kuta iyaṃ visṛṣṭiḥ |
> arvāg dēvā asya visarjanē nāthā kō vēda yata ābabhūva ||6||

Translation:

Who knows with certainty what is being spoken about here? How did this distinct creation arise? The energies were created later, then who knows when it first came into being? What observed it to come into being from an indeterminate to a determinate, who knows?

If this is read correctly, it will be realized that our sthotrams, mantras and Upanishads do not talk about "devas" as "Gods," in the way we understand it in the current world. "God," the way we understand the concept seems to have been an alien to they, who wrote these sthotrams, mantras and upanishads. It definitely does not look like they had any concept of divine God at all and especially a "God" to be followed without questioning! They seem to have only wondered about the truth, what existed before we came into being and been awed by what they might have found. In my view, they cannot be talking about such an in-depth concept such as that in the Nasadiya Suktam, in some verses and fall back to talking about shallow, superstitious, mindless traditions, pujas and commandments in another.

This only brings out the fact that the power of the concepts that were written in these sthotrams, mantras and Upanishads had so much of truth in them that even in their mangled form, they still continue to radiate the truth that was researched and written.

Hence, in this book, I aim to lay the results of my research of these sthotrams, mantras and upanishads passed down through ages, to restore back the original possible concept that they who wrote it, tried to convey.

I believe a study of Shiva and the related concepts is the first step towards understanding this environment and the link to the environment of truth. Hence, a research into Shiva using the sthotrams, mantras, ashtakams and Upanishads.

Setting the Context

The meaning of science according to google is "the intellectual and practical activity encompassing the systematic study of the structure and behaviour of the physical and natural world through observation and experiment." The other definitions include "a systematically organized body of knowledge on a particular subject." It is to be noted that the subjects we want to study or gather knowledge on, is also defined by the same intellect! I am reminded of a situation where my boss said "Please raise your hand if you have forgotten to fix a bug!" If I have forgotten, I have forgotten. How can I remember that "I have forgotten" until something external triggers the memory of the bug? Similarly, the intellect can only study that which it knows about! This, very subtly, tells us that inherently we need to have a "thought about something" and science is just a means of proving or disproving that thought, using intellect and understanding of the resources available. The intellect by itself is not responsible for the knowledge. Such a knowledge is highly error prone and directly leads us to the "problem of the observer."

THE PROBLEM OF THE OBSERVER

According to Wikipedia "The observer effect is the theory that simply observing a situation or phenomenon necessarily changes that phenomenon." I think we need to examine this statement very carefully. If we do, we will find that we have to reverse the importance given to the object and subject and state this a little differently. The "observer effect" is where the "observer" is given more importance than *that which is being observed.* The fact remains, "that which is being observed has always been and will always be what it is," it is the observer that is limiting. The observer is limited by what properties it can or cannot observe. Hence, all that adding an observer does, is, *focus our intellect on those properties which can be observed.* This effect is similar to an optical illusion. Depending on the perspective of observation different views are perceived by the brain of the *same* drawing. It should

be noted that the drawing has not changed in any manner. This is the same concept that is propounded in the "Advaita Philosophy." Neither does the immortal become mortal nor the mortal become immortal. It is just the perception of "same immortal" that is changing. The immortal has and will always be what it is.

In the modern world we study physics, quantum physics, particle physics, inorganic chemistry, organic chemistry, various forms of mathematics and a large number of scientific topics. Yet, all of these studies only relate to "sense-able reality" around us. Understandably so, because our intellect knows and is interested only by this known reality. It is via this same intellect that we extend our imaginations to build more and more, classifying this known reality, infinitely further away from the source or the truth.

This reminds me of this: If, I am playing a virtual reality game and I feel hungry, can I conjure up a burger within the virtual reality game and eat it? Will my hunger be satisfied? Just so, I can read and solve a lot of problems, read and improve my intellect and prove a lot of science inside this "reality" around me. But, that which causes this reality has not changed! It has stayed always the same, external to this reality around me and inaccessible to me via these sciences.

What is that "which causes this reality" around us? While it can be argued that "quantum physics" is attempting to study just this, we need to ask ourselves the question, "why will quantum physics not lead us into one or other of the infinite threads that have been spawned from studying many other physical concepts?" I think, what we need to understand is that even with study of quantum physics, we have not moved away from the underlying concept: "I am the observer" and the "quantum particles are the observed." This means "I am still limited by my observing capabilities, which are: my senses, my judgement, my expectations and my brain or in other words the manas"! I label such a study as "study with the manas."

LIMITATIONS OF STUDY WITH THE MANAS

It may be asked, "what is wrong with study with the manas?" and the simple answer is "There is no problem when we want to study this world around us." Otherwise, the problem is simple and straight-forward. Study

with the manas involves the study of *"what was"* as opposed to *"what is."* Let me elaborate.

What do we perceive? That which the sense organs can sense. What can a sense organ sense? That which has already happened in this environment (Whatever way we define the environment) around us. It is similar to the IoT sensors that are installed in the various applications. They can sense what the "temperature is – an event that has already happened" or what the "pressure is – an event that has already happened." Similarly, we can hear what someone has said, or we see the leaf that has already sprouted or feel the touch when something has already touched us, or feel the pain when already the skin was cut and so on. Hence, "study with the manas" will always be study of only one thread that has already occurred. There is a very good Sanskrit saying "yad bhavam, tad bhavati" which translates to "What has started happening, will happen." Since, we only know when something "has already started happening," that which we sense will follow its full path and finish happening and we can do nothing about it.

Similarly, in "quantum physics," the modern world is only studying "what already is or was." This is in direct conflict with what "quantum physics" is supposed to be, namely "all possibilities exist until an observer is present." We need to study and view from the perspective of "a state where all possibilities exist" to know more, not when "already one of the infinite possibilities is already chosen by an observer." Hence, the study of quantum physics has to be without an observer that is without "I"! The major problem is we cannot *sense* possibilities. We can only *imagine* possibilities which does not augur well with science. So, the question becomes how do we study that "which is" before the observer comes into effect?

The next problem with "study with the manas," can be best understood when we look at the way we solve puzzles such as sudoku or hitori or simple crossword puzzles. The fact remains that when the puzzle is created, simultaneously the solution to the puzzle also exists. But, given the sequential nature of our brains, we always tend to solve puzzles sequentially, one step at a time. Understanding is sequential. We need to be at a certain level of understanding before then next step in understanding comes. We can multi-task, that is do many tasks at the same time, but one task is always done sequentially.

For e.g., if we take a sudoku puzzle, we need to logically infer the first set of numbers and their positions, before the next set of numbers and positions are inferred. We cannot run them in parallel and know the solution immediately.

Hence, learning is also only sequential. Experimentation and conclusions based on experimentations are also processed by the brain sequentially. For e.g., we had to first understand the existence of atoms and only later on understand or learn the existence of electrons and protons and neutrons and only after this start with understanding the existence of photons and so it goes one after the other. This is sequential understanding. Yet, the world exists simultaneously. Whatever makes up photons or Higgs boson or Higgs field exist simultaneously with atoms which exists simultaneously with the higher human being etc. A small change in one implies a change in the all the others simultaneously. Given that brain can only process sequentially, we are limited by what we know of until now.

I believe, the environment, *"the one that is before the observer comes into effect"* is called the "unmanifested" or the "Bhairava." Whatever it be called, the question still remains, how do we study this environment if not study with the manas?

TATVAMASI

We find that we have still not cracked the challenge of finding how to study this environment! It cannot be studied using the standard methodologies of observation and experiments. Definitely not with experiments by being within this reality. Definitely not sequentially by experimenting and proving one at a time, in this case we either will miss out information or we will be studying forever without reaching anywhere. So, we need to look for something out of the box.

Irrespective of how much the Upanishads, sthotrams, slokas, mantras etc., from the ancient texts have been misrepresented, distorted or typecast as superstition or mistranslated or tried to be fitted into what goes for science in the modern day, they contain grains of this truth, beyond the modern day science which shines through all these

distortions that cannot be ignored. One such is what is said in one of the many illuminating sruthis:

> acintyam cintyamāno'pi cintārūpam bhajatyasau |
> tyaktvā tadbhāvanam tasmāt evamevāham āsthitaḥ ||

Translation:

Thinking of the unthinkable only forms a thought of the unthinkable. Hence give up that thought knowing it will not last.

It takes a very long time for the implications of this verse to sink in. On the surface of it, the meaning of this verse is seemingly very simple. The significance and far reaching impact of this verse is scant realized. The primary implication is that **thought** and **knowing** (for lack of any other word) are not the same. Can knowing exist without thought at all?

Even more significant implication of this verse is that, the *formation of thought* is not the only way of *knowing*! In the context of science, observation and experiment is a form where the **remote** (**para**) is examined external to ourselves, to *trigger the formation of thought*. When we are talking about the *unthinkable, or rather the unmanifested,* we cannot trigger anything externally, because then an observer comes into play and then we are not examining the unmanifested!

Here is where tatvamasi comes into play. The **Tatvamasi**, is a concept which is multi-dimensional. Keep trying to understand it in various contexts and it takes on different meanings. The basics first. Tatvamasi is split as tat + tvam + asi = that + in me + is. So simply translated it is, **"I am that"** or **"that is me"** or **"that is in me."** All the forms of translation hold. Either "I" or "that" is given importance, based on the context.

The most intriguing implication yet, of tatvamasi is with respect to the study of the unmanifested. It implies, ***If, that remote, that I am experimenting on, is equivalent to this "I," then experimenting with this "I" should be the same as the experiment with that "remote."***

An observer is only required if the process of knowing goes in the sequence of steps as: experiment with remote objects → trigger thought formation → understand → know. Such a sequence of knowing obviously comes associated with the problems of the observer effect. This is *"the*

externally triggered knowing," the same as *"study with the manas"* as we described before.

When we look at it from the perspective of the unmanifested, the experimented is the same as "I" or what is in **that** external is also **within** me. So, the sequence of knowing can as well have been reversed and been in the steps: "I am that" → knowing → understanding → thought formed. **This is an unravelling process, that starts with "I am that" and hence "I transform to know."** Here, we are never observing "that," we are only *being* "that." Hence the observer effect does not happen.

Also, while the study with manas is a sequential study, study by being or using tatvamasi, is where, understanding is simultaneous or understanding of a snapshot of the whole. It is "all or none." By being, we are aware of "all that is till the level that we have reached." The difference is the same as reading a paragraph and seeing a picture. The picture conveys all that needs to be conveyed at one shot, while in a paragraph we have to read, process, understand sentence by sentence till all description is read and understood.

The concept of tatvamasi is very tough to experiment with and definitely cannot be proved to others. It only involves a transformation of the "I." Yet, it is very important to understanding the unmanifested or the environment of all possibilities. In no other way can I think of eliminating the observer, which is important to study the environment of all possibilities.

PARA BRAHMA TATTVA

Now, the questions that obviously arise are, what is *"I am that"*? *How do we start unravelling "that" and how does it become the study of the environment of all possibilities?*

The other very interesting concept that is propounded is the "Para Brahma tattva." Translating it: Para = remote, Brahma = create, tattva = principle or the "principle of creation of the remote." Instead of Brahma, it can also be said as "brahman" which then translates to "truth," so, it translates to "principle of the remote truth." Either way, this implies the same thing.

So, what does this mean? To understand this, we need to ask ourselves only one question **"How many thoughts do I have that are purely related**

only to "I"? The answer is *"none"*! *Yes, none*. You can have a thought that says "I want to eat that banana" which seems like it is only related to me. But you see, it only ties the "I" with the remote "body" and from there ties it to the remote "banana." You can have a thought "I am the most important person" which seems like it is only related to me. But, again if you think carefully think back, "important" is only when it is relative to a lot of other things which is either the "society" or "friends" or some set of remote truth other than the "I." You can have a thought "I am hungry," this too is tying the remote stomach to the "I." You can experiment with any number of thoughts. *In this form or simply in the environment of reality, we always only create remote things, things different from "I" and tie it back to the "I."* This is the principle of creation of the remote!

The Dakshinamurthy sthotram – Dhyan says:

maunau vakyAm prakatita para brahma tatva yuvAnaM
varShiShTAnteva sadraShigaNairAvrutam bramhaniShTaiha
AcAryendra karakalita cinmudraAnandarUpam
svAtmArAman muditavadanam dakshinAmUrthymIDe

Translation:

In the silence of the thoughts is revealed the strength of the concept of remote creation. At the end of this strength is perceived this encompassed multitude, intent upon creation, guided by the senses, the doer is impelled with the impression of awareness in the form of happiness, rejoicing in the description of one's own self, is called Dakhsinamurthy.

Isn't it true that we are always driven by our own impression of happiness which in-turn is formed because of input given by the sense organs? When we try to reduce our thoughts to zero is when we find how strongly they come back, getting created over and over again! It takes a lot of strength to know and think about the "I" without thinking it to be the body! The point very simply is that we tend to confuse the "I" with the identity of our body. We have not stopped to ask ourselves "what is this 'I'?"

How does this help us? The "Para Brahma tattva" and "tatvamasi" are very core to traversing the layers to be unravelled. The process goes like this: "I am that (let's start with body)." Now, knowing "I am the body," I ask

myself "who is creating the body," I find: "the body is being created by the manas" so "the body becomes the para and manas becomes I," so we unravel to the next level "I am that (the manas)." Now, knowing that "I am the manas," I ask myself "who is creating the manas?," I find "the manas is created by the awareness or Cit" so "the manas becomes the para and Cit becomes I" and so on it goes. The Chandogya Upanishad's Sanatakumar's dialog with Narada depicts just this and indicates the various steps to be unravelled. Read more about it in https://ancientinsight.online/2018/02/20/chandogya-upanishad-sanatkumars-dialogue-with-narada/.

Thus we switch between "Tattvamasi" and "Para Brahma Tattva" to keep delving deeper till hopefully we get to the point of unmanifested or the environment of all possibilities. This is one science in which philosophy and science merge and we start studying the "I" in ourselves as "just one of the possibility" from the "environment of all possibilities." Following this path, of "para" or remote, we find that "Shiva" becomes the first stepping stone when going from this reality into the environment of all possibilities. It is said of Shiva:

Vande Deva Umaa Pathim Suragurum, Vande Jagat Kaaranam
Vande Pannaga Bhooshanam Mrugadharam, Vande Pashoonam Pathim
Vande Soorya Shashanka Vahni Nayanam, Vande Mukunda Priyam
Vande Bhakta Jana Ashrayamcha Varadam, Vande Shiva Shankaram

Translation:

Regard the energy that is knowledgeable to be the master of tranquillity and the reason for the existence of the universe

Regard the enhanced pulsation that supports beings, the master of the living beings

Regard the direct and reflected light with guiding fire, that is near equilibrium

Regard the distributed protected living space, the uncertainty of Shiva

In this book we will explore till this Shiva and I hope the meaning of this above verse comes out clearly as we go each step in exploring Shiva.

Deciphering the Environment

The first step towards studying the "process of manifestation of the unmanifested" is to recognize the parameters of the study. The resources available to conduct the study, as we saw, the "tatvamasi" method which cannot use anything external to ourselves. We find that every time we need to describe something around this study, we have to refer to what is called "environment(s)," and invariably, over the course of previous chapters, I have been referring to environment(s) in various forms. Thus, the first question that arises is, "What are these environment(s)?"

In general, "an environment" is defined as the surroundings or conditions in which something operates. For e.g., earth is an environment in which living beings prosper, the Large Hadron Collider provides an environment in which fundamental physics principles are experimented and so on many environments can be defined. We need to define the properties of this environment that we want to study and the restrictions and limitations under which we can study this environment when using the "tatvamasi" approach.

Modern science is limited to the study of matter. Accordingly, the environment in which we live, is considered to be purely consisting of different forms or compositions of energy or matter or anything that is "sense-able" by the human brain or manas. Yet, if we read the ancient texts, matter and energy just scratches the surface of the environment. Matter is not even mentioned as a possible topic that requires attention. It either starts at the spirit, the waking state or energy forms. Anything else other than these starting points are considered to be already understood and discarded as trivial.

As an aside:

> *The major difference to recognize in "researching by being or tatvamasi" instead of "researching by experimenting," is that, in the latter you can pre-set the boundaries of the study, while in the former you have no control over the state of experimentation. What is present has to be studied as is.*
>
> *In an experiment based study, the state is stripped down to that which is the simplest state. This simple state is studied and the results extrapolated to more complex states. But, such a study is accompanied by the disadvantage that, what is studied need not be representative of the actual. It is only an un-validated assumption that the stripped down version is representative of the actual state. Validation of the assumption can be done, but this leads us into a recursive set of experiments which gets us to no conclusive end.*
>
> *When studying using the "tatvamasi or experimenting by being" we have to understand that we study the states "as is" without altering what is happening. As in any analogous process, there is no abrupt change from one state to another. What exists is a function based on which one state decays and another function based on which the second state comes into being. We cannot also assume that at any given point only one idea is manifesting. This study then is a study of multi-threaded, non-mutually exclusive, continuous change in the states in its entirety. The techniques for such a study is completely different. For e.g., it is possible that by being we can "influence what is" and compare the difference to understand, but the whole has to studied or nothing at all can be studied.*

We start with what we currently have and know. At a first glance, when we see this world as a manifesting of the unmanifested, we can obviously identify three states, namely: it starts at a state where only a set of possibilities exist, moves on to a state when one or more of those possibilities start to go towards manifestation and ends at in state when that possibility has manifested. The Bhagavad Gita talks about the three states in this verse below:

> avyaktadini bhutani vyakta-madhyani bharata
> avyakta-nidhanany eva tatra ka paridevana

Translation:

That which has become is unmanifested and is manifested in the middle. Why lament for that which is therefore unmanifested without end.

We move further now. The above indicates to us that the states are circular, hence forming the infinite cycle. The unmanifested starts becoming manifested, goes towards manifestation and then starts going back into unmanifested before it becomes unmanifested and the cycle continues. Now that we have this confirmation, we continue to define these three states we have:

1. "The void – This is called shunya," this is where nothing is actually present, but the possibility of being exists.
2. "The becoming – This is the Purusha," this is when the possibility starts to manifest and ends when it has completed manifesting.
3. "The become – This is the Prakruti," this is when the becoming has completely manifested.

There is a state before the void, where nothing exists, even the possibility of being. This, is considered to be "the truth or the Brahman state" and this state is not the topic of this research.

The question that arises here is "What is manifesting?" and the only answer I can think of with the current information is "the possibility of the truth being perceived in a certain state." As we keep moving forward, this will keep changing to become clearer.

If we form, a set of, "a void, a number of possibilities in the state of becoming and a number of possibilities that have already become," this is the environment of study. This is what is called in these works of literature as "kshetra" or "the environment." Maybe various kshetras can exist and these environments are exclusive to each other. Yet, we can only know and study this environment or "kshetra" we are in. This is the first level of understanding we have and we will start from here.

The Bhagavad Gita has a chapter devoted to describing "kshetra" and we will delve deeper into this, in this chapter to understand the "kshetra."

AWARENESS OF THE ENVIRONMENT

We were researching the environment, so why have we shifted to awareness? As we put down what we understood, we need to be conscious of the fact that "I" is a huge part of this "understanding." To define the environment, we need to understand "How did "I" become aware of the environment?," this is the process of tatvamasi.

To answer this, the question we need to ask ourselves is "what is awareness?" Is awareness due to knowledge or knowledge due to awareness or are knowledge and awareness the same? It should be noted that I talk about it as knowledge rather than intelligence. Knowledge is inherent and is present irrespective of whether we consciously translate the knowledge to externally understandable description or not. Intelligence is pulling together of various pieces of knowledge to conclude a third piece of knowledge by applying logic, logic in itself being again just another knowledge.

According to the steps in Sanatakumar's dialogue with Narada in Chandogya Upanishad, "Cit" or awareness comes after "Dhyana" or focus and moves forward to "Sankalpa" or direction and then "manas" and then "vag" or description. There is no explicit "state" for knowledge. This leads me to believe, that knowledge is the same as Cit or awareness. If "I" was not aware, will knowledge exist? An in-depth understanding of knowledge and awareness can be got from the first part of Bhagavad Gita's thirteenth chapter.

The Environment and the Knower of the Environment

The chapter 13 in Bhagavad Gita, known as "Kshetra-Kshetragyana-Yoga" starts with describing the environment and the knowledge of the environment. According to the Bhagavad Gita's chapter, there is "the environment" and "the knower of the environment":

idaM SareeraM kauntEya kShEtramityabhidheeyatE |
EtadyO vEtti taM praahuH kShEtragnya iti tadvidaH ||1||

Translation:

This body is measured only in this environment. He who knows this, he considers the knowledge of the environment is the same as that.

The first very important concept to understand here is "kshetragnya," which can be translated as "environment knowledge." It should be noted that "knowledge of the environment" is not the same as consciously recognizing and understanding the environment. This is an inherent recognition of the various properties of the environment and reacting, without applying any logic to it.

For e.g., adding two electrodes (positive and negative) to an electrolyte creates a voltage between the two electrodes. For e.g., carbon and metal oxide electrodes in an organic solvent with lithium salt. In such a system, inherently carbon takes on a negative charge and metal oxide a positive charge. It should be noted that the electrodes by themselves without the electrolyte has no voltage between them. There has to be an intrinsic recognition of the properties of the environment around it, by carbon, metal oxide and electrolyte to create this system. The knowledge can be observed as the change in molecular arrangement, the production of ions and so on. The elements innately need to detect the state of the environment and react for such a battery system to be formed. This is called "kshetragnyan" or "knowledge of the environment."

The next important point to understand here is the "measurement of the body." As the verse rightly indicates, this measurement is only possible within a given environment. Take away the environment of organic solvent with lithium salt in the above system, no measurement can be made of voltage between the electrodes. Thus it is seen that measurement and knowledge is the same. Without perception, knowledge is not present to react. Perception is just a measure, an observation of the detectable environment around it.

kShEtragnyaM chaapi maaM viddhi sarvakShEtrEShu bhaarata |
kShEtrakShEtragnyayOrgnyaanaM yattajgnyaanaM mataM mama ||2||

Translation:

Knowledge of the environment rather than knowing of the I is present across the environment. The thought of "I" is that knowing of the environment of the knowledge of environment.

In this verse we are shown the difference between "I" and "knowledge of the environment." While, the electrodes in the battery had the "knowledge of the environment" around it to act appropriately, there is no "thought"

associated to the electrode. It is a measurement or perception (which is just self-measurement) and a reaction. This verse claims that "such" is the "knowledge of environment" that is existing across the whole environment. Further, it says, if we created a secondary redirection environment of all such measurable knowledge of environment, then that becomes a "thought" and thus is started the thought of "I." Hence, "awareness" is "knowing the environment of the knowledge of environment" as opposed to the first level knowledge of the environment. The below picture shows the two levels of knowledge:

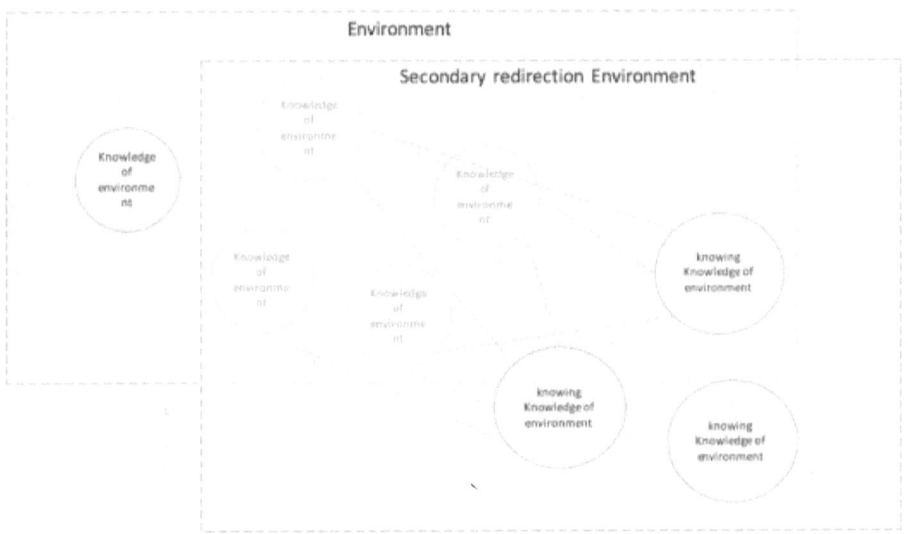

Figure 2: Two Layers of knowledge of Environment

It is a pertinent question to ask, "why would the secondary redirection cause 'awareness'?" Is just this secondary redirection enough to cause "I"? The subsequent verses extrapolate on this secondary environment.

tatkShEtraM yachcha yaadRukcha yadvikaari yataScha yat |
sa cha yO yatprabhaavaScha tatsamaasEna mE SRuNu ||3||

Translation:

That environment due to this, will appear to be changeable from anywhere. This environment is also such that, because of that influence, in that equilibrium is perceived.

"That environment" here refers to the secondary environment that is formed by knowing the knowledge of environments. It says that the environment appears to be changeable due to this secondary redirection. The first question that arises here is "why should this cause the environment to appear as if it is changing?" The underlying requirement for change is a *"reference point."* Without a reference point, knowledge, just is. In the example we were looking at, the measured voltage across the electrodes is a single value. Change in voltage or delta voltage can occur only if the previous value of voltage measured is present to compare the current value with. Thus, the first layer of knowledge of environment provides current values to a finite second layer of redirection and thus introducing the concept of change in the second layer of redirection.

It is interesting to note that because of this change, equilibrium is also introduced as a concept. As I have indicated above, if a reference is not present, then knowledge or environment just is. A reference is also needed to perceive equilibrium. How do we define equilibrium? The word "samAsena" describes it very well. "samA" means equal, thus if we do not detect a change, then, that should be in equilibrium.

We find in nature every change either increases or decreases, whichever the case be and finally settles on a certain value. In our example, the voltage settles at a certain value based on the electrolyte and electrodes used. There is a series of change involved between creating the system and the voltage reaching the final value. Hence, this verse says that this introduces a change and then settles into equilibrium. More towards this later on.

RuShibhirbahudhaa geetaM CandObhirvividhaiH pRuthak |
brahmasootrapadaiSchaiva hEtumadbhirviniSchitaiH ||4||
mahaabhootaanyahaMkaarO buddhiravyaktamEva cha |
indriyaaNi daSaikaM cha pancha chEndriyagOcharaaH ||5||
ichCaa dvEShaH sukhaM duHkhaM saMghaataSchEtanaa dhRutiH |
EtatkShEtraM samaasEna savikaaramudaahRutam ||6||

Translation:

Many such series of change appear different and thus separate, which certainly causes instability in the parts of the thread of creation.

Great many that have become also unmanifested to the intelligence of the 10 sensory and 5 perceptible senses, supporting the union of like dislike, happiness, sadness, in this environment is illustrated as equilibrium and change.

This brings out another very core point. In our sample we have a knowledge by the anode electrode, the cathode electrode and the knowledge associated with the electrolyte. Each of them are strung together by the system called battery in the secondary redirection environment. If we had not considered stringing them together into a single knowledge and had considered them be different, the battery would not have been created. In general, in this secondary redirection environment we look at these "knowledge of environment" as distinctly different and separate which then causes a disruption in the thread of creation.

If we start looking at a huge number of such knowledge that are present in this secondary redirected environment, both that are unmanifested to the intelligence and manifested to the intelligence (in the form of sensory perceptions), we find they are just the various illustrations of the change and equilibriums that have got established because of this two level knowledge of the environment. It should be noted, that the sensory perceptions only detect either change or equilibrium.

Map of Knowing the Knowledge of the Environment

This part of the chapter concludes by saying:

avibhaktaM cha bhootEShu vibhaktamiva cha sthitam |
bhootabhartRu cha tajgnyEyaM grasiShNu prabhaviShNu cha ||16||
iti kShEtraM tathaa gnyaanaM gnyEyaM chOktaM samaasataH |
madbhakta EtadvignyaayamadbhaavaayOpapadyatE ||18||

Translation:

The undivided also becomes situated in this divided, the supporter of the become also is that knowing that potency is also absorbed. Thus in pure summary, knowing knowledge of this environment is unstable distribution of that coherence, becoming instable will destroy and perish.

This is best understood by comparing this statement to the healing of wounds. It starts with first the knowledge of the aberration of the skin, pain is still in the numbed state, from there it goes towards the mind knowing the pain and writhing in it, from there it goes towards the pain decreasing as the aberrations dry up and the skin heals and the wound dies out. The undivided coherent knowledge of pain breaks down into its constituents and its potency gets absorbed back into the environment of become. While pain brings the concept out succinctly, the same is true with happiness and any other knowledge. It starts with the becoming of the coherence that then reaches the highest point of coherence before breaking down and getting absorbed. Thus we find that the knowing of the knowledge always follows a pattern where it divides and subsides.

Another important point bought out here is with respect to the redirection itself. We can ask ourselves, if a secondary redirection can happen, then why not an infinite redirection recursively? So, what will the tertiary redirection lead to? Yet, this is not considered in these texts anywhere! This verse gives a glimpse of the answer. Coherent knowledge is unstable and always divides and subsides. Even if a tertiary environment can be created out of the knowing of the knowledge, it just subsides down into its constituents. The various knowledge of the environment are unravelled to form only two level hierarchy.

The secondary redirection environment can be viewed as a distribution "map of knowing the knowledge."

Figure 3: Distribution of knowing the knowledge

TIMELESS ENVIRONMENT

In the science of the modern world, we tie time tightly to space and call it space-time continuum. Time is considered to be the fourth dimension of space. But strangely, while reading and translating the Upanishads or the Gita that refer to this environment or kshetra we find that there is no reference made to "Time" itself as a separate entity. The "Chandogya Upanishad's" series of steps stated by Sanatakumar, includes force, matter, entropy, space and persistence, but time is missing from the series. The question is "Why?." The Upanishads and sthotrams definitely seem to talk about the environment, the process from unmanifested to manifested, it also talks about space. But time as we know it is noticeably missing! The strangeness is further emphasised due to the fact that both "matter" and "time" is missing from any in-depth discussion.

While the "Kala Bhairava sthotram" and "Maha Kala Bhairava sthotram" refer to "kala," which translates to "time," the time defined in these sthotrams is distinctly different from what we understand as time in the modern world. The "Maha Kala Bhairava sthotram" has the following about time (Read more about these sthotrams in the next chapter):

> Kham Kham Kham Khadga Bhedam, Visha Mamruta Mayam
> Kaala Kaalam Karalam

Translating:

kham is the differentiating between the disturbances causing the illusion of changing and the unchanging and hence this immense time

This seems to tell us that differentiating between various disturbances is the reason for this immense time. The raises a very simple question, "Is time real or is it just an abstract, formed because of the sensory perception of the brain?" If time is just abstract, then studying time will get use nowhere, since we will still remain in a dimension in this world of manifested. In such a case, it makes sense that "time" is not mentioned in these various texts.

Thinking about "time" from this perspective i.e., time as a perception rather than reality, and looking at the kshetra as a conglomeration of the three states (void, becoming and become), we start having a glimpse of how the abstractness of time is an inherent concept of the environment.

It almost seems as if, "the become" is equivalent to that which we refer to as "past," that which cannot change. We sense it using our sense organs, store it using our memory and use it as an experience. "The becoming" is equivalent to that which we refer to as "present" and "The void" is equivalent to that which we refer to as "future." Thus time can be abstracted as either a set of "past, present and future" as how we do or a set of "void, becoming and become."

Though, we should recognize that these are not equivalents to each other. There is a huge difference in defining time with the concept of "void, becoming and become" as compared to defining time using "past, present and future." In-fact they are orthogonal to each other. In a highly simplified form, if we viewed this "entire masse of all possibilities, those that are becoming and those that have become" as a NxM matrix with N rows of changes starting from the unmanifested and going towards the manifested and M columns of varying steps involved in manifesting from the unmanifested, then the "void, becoming and become" definition, is the perspective of the rows and the "past, present and future" definition, is the perspective of the columns. Whether the rows or columns is perceived depends on who perceives the matrix! Below diagram shows the difference.

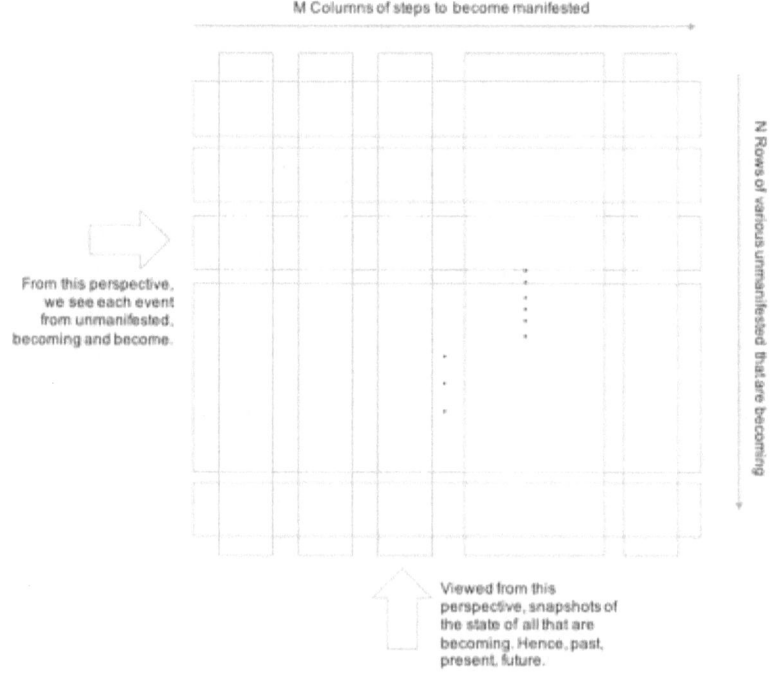

Figure 4: Matrix of all that is Becoming and Become

If the "knowing of the knowledge of the environment" is analogously continuous, it gives the illusion of time as we perceive in the "past, present, future" definition. Yet, this perspective takes us no further into understanding the environment. Instead of perceiving snapshots of the environment analogously, if we follow through on a single thread of "void, becoming, become," we can reason out that "knowing of the knowledge of the environment" is in effect just "differentiating between various disturbances" as the unmanifested becomes the manifested. If sensors exist that detect these disturbances, that becomes "knowledge of the environment." In the later chapters we will see how this is possible.

The next major difference between the two definitions of time, arises in the position of observation. When we start perceiving the environment as "void, becoming, become," the position of observation of "the becoming" has changed. In the "past, present, future," the observer is positioned *after* "the fact." So the observer perceives all that has already become and perceives that which is still becoming while the observer can only anticipate the next step. In this perspective, the observer never perceives the void. Whereas in the "void, becoming, become" perspective, the starting point of perception is "the void or all possibilities," i.e., the position of the observer is *prior* to the fact. Thus the observer is able to go through the path that the observer wants to follow through to completion.

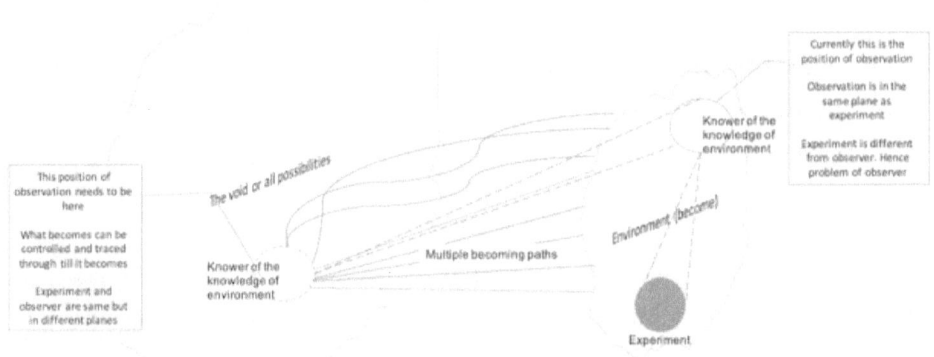

Figure 5: The Various Positions of Observer

This gives better control to the observer to orchestrate the environment as needed by being able to choose the possibilities to run and trace through. Here, the observer becomes an asset who can better control the experimental parameters as opposed to the original experimentation, where the observer is detrimental to the experiment. When the observation position moves to the void, the observer no longer stays at the level of "knowing the knowledge of environment." "Knowing" can only occur when something already exists. When it shifts to the void, the observer is no more just observing but in total control of what becomes and starts becoming. The most important question here is, can an "observer with an 'I'" exist at all in this position of the void? This is the question we want to search an answer for and thus the search for Shiva.

The Become and the Becoming

The chapter 13 of Bhagavad Gita can be split into two sections. The first that describes the environment and knowledge of the environment as I have explained previously. The second section is related to the nature of the become (Prakruti) and the soul of the becoming (Purushah).

>prakRutiM puruShaM chaiva viddhyanaadi ubhaavapi |
>vikaaraaMScha guNaaMSchaiva viddhi prakRutisaMbhavaan ||19||
>kaaryakaaraNakartRutvE hEtuH prakRutiruchyatE |
>puruShaH sukhaduHkhaanaaM bhOktRutvE hEturuchyatE ||20||
>puruShaH prakRutisthO hi bhunktE prakRutijaanguNaan |
>kaaraNaM guNasangOsya sadasadyOnijanmasu ||21||
>upadraShTaanumantaa cha bhartaa bhOktaa mahESvaraH |
>paramaatmEti chaapyuktO dEhEsminpuruShaH paraH ||22||

Translating:

Both the nature of the become and awareness that has penetrated this nature has no beginning. Due to the distribution of change in properties this penetration of the nature is possible.

The cause for of action becoming acting is said to be the nature of the become, while the cause of being in the state of experiencing happiness and sadness is said to be awareness.

But it is due to the nature of awareness that the property of experiencing the nature of the become is born, always triggering an association to that property to be formed

Further it should be seen, that acquiescing to experience the prime potential, awareness yields to be joined with the remote body later on

This is a very revealing when considered with the ending of part 1 of this chapter. If we see this environment as distribution of knowledge, and awareness as a knowing of the knowledge, then we are **NOT** looking at any beginning or an end of knowledge or the knowing of the knowledge. We are looking at a distribution of awareness of the knowledge, a distribution where the strength of awareness waxes and wanes. Say we were able to project the strength of awareness on an axis against knowledge, we are looking at a visualization like below with troughs and crests. The troughs being points where the strength of awareness is high and crests being points where strength of awareness is at a low.

Figure 6: Troughs and Crests of Awareness

It should be stressed that this is a distribution of awareness and not the knowledge of the environment. It should be further recognized that if we have only continuously equal distribution of knowledge with no change, awareness is not possible. There needs to be a reference knowledge from

where the change in properties can be detected and thus the concept of awareness can exist. While we found previously that if we did not have a reference point, awareness cannot exist, we should also recognize that even if there are no change in properties, awareness cannot exist. See the diagram below for reference:

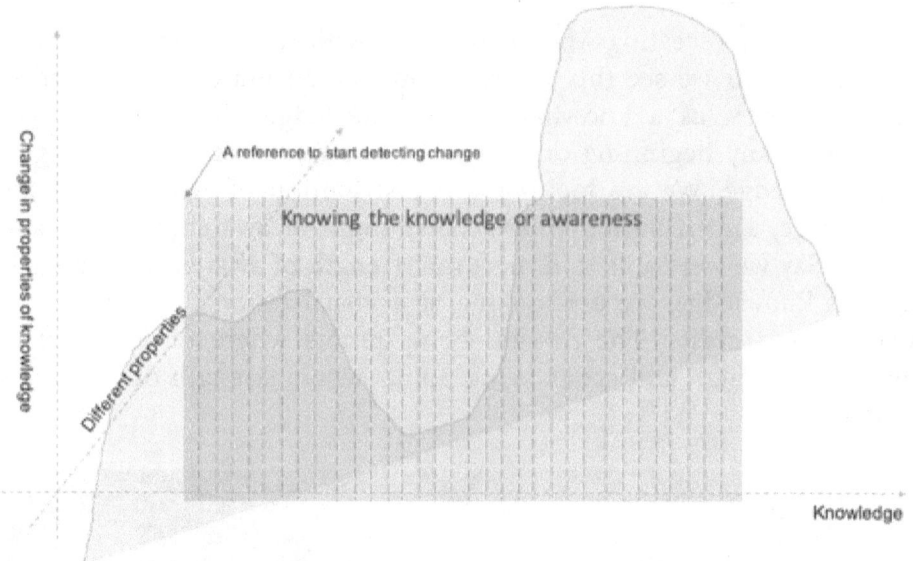

Figure 7: Underlying knowledge, Overlaid with Awareness Only if a Reference Point is Present

In the diagram, we have a co-ordinate system with the knowledge on one axis, the different properties of knowledge on the second axis and the change in properties of knowledge on the third axis. For now let's assume we have some data in some irregular form of distribution (See formation of environment for how this is formed). If we projected awareness on this co-ordinate system, we can see what these verses are trying to tell us.

When we look at this system from within the system, i.e., by being a part of the system, it seems as if, change in nature of knowledge is the reason for action, but in-fact, the underlying co-ordinate system has not changed at all. It is the traversal of awareness over that co-ordinate system that has simulated the concept of change, which in-turn has caused experience. The nature of this awareness is such that, there is a

reference point and a comparator against that reference to detect change in properties, without reference awareness is not possible. If we now associate sensors to detect this change, we are looking at a body. For e.g., the eye detects change in visual frequencies, ear detects change in sound frequencies and so on.

> ya EvaM vEtti puruShaM prakRutiM cha guNaiH saha |
> sarvathaa vartamaanOpi na sa bhooyObhijaayatE ||23||
> dhyaanEnaatmani paSyanti kEchidaatmaanamaatmanaa |
> anyE saaMkhyEna yogEna karmayogEna chaaparE ||24||
> anyE tvEvamajaanantaH SrutvaanyEbhya upaasatE |
> tEpi chaatitarantyEva mRutyuM SrutiparaayaNaaH ||25||

Translation:

Also know this, awareness, nature of become along with it properties, all of these is existing, it is not that they become or is produced

A focussed self perceives a part of this self of selves, others yield to an union with rational action

Perceiving, several other unformed is anticipated, and by projecting on this abundant perishable, is perceived by the remote

In the figure above, we see that none of what we have drawn are produced, created, have become or anything of that sort. They are just present. Awareness is the only plane that is traversing due to detection of change. Also to be noted is that the change detection is possible only due to the reference anchor. This causes the illusion of becoming and become. This is like our old movies that recorded a car being driven, in just the studio. There is a static background scenery with a model of a car in front of the scenery with a person in it. The camera pans from one end to the other end to simulate the idea of motion.

If we focussed, we can become an observer who perceives the nature of the become or the self of all the selves or that top level where no reference is present. Normally we stay at the current plane of awareness with logic and rationalization. It is like an optical illusion with two views,

focus, you will see one picture, but normally you see that which comes naturally to you as perception.

Changing the perspective and plotting the awareness and then look at the planes of observation, we are looking at something as below:

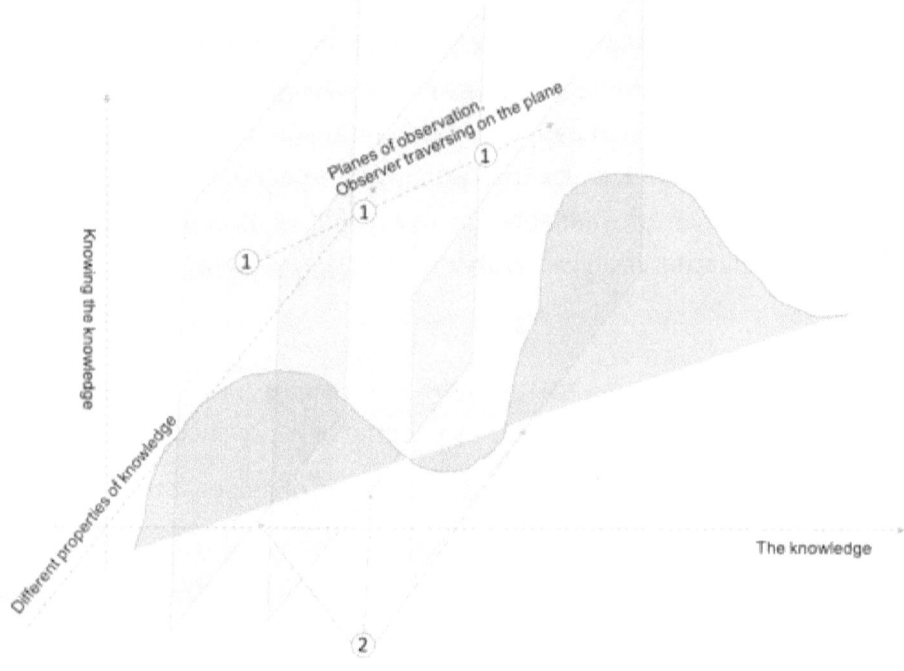

Figure 8: Different Positions of Observation

At every plane we know all the previous values, but not the forward values. Normal behaviour is of observer "1" that traverses with the plane and sees only the current and previous change in knowledge. We need to focus to rise above these planes of observation into observer "2," that can see the whole picture or the self of the selves.

The perspective drawn in these above figures is a cross-sectional, simplified perspective of the nature of the become being projected on a three dimensional axis. We will have to imagine an infinite dimension infinity where a distribution exists of infinite characteristics. A 3D projection with cubes may look like below:

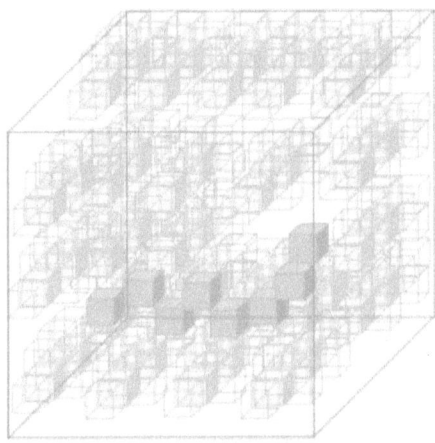

Figure 9: A Regular 3D Distribution of Environment, knowledge of Environment and Awareness

This is a regular distribution, created using regular simple cubes, each cube with its various colours representing the change in property at that point. In truth, the cubes themselves can be multi-dimensional and represent the many characteristics that exist around us. In this the cubes are arranged in a regular pattern within another regular cube, but can be made irregular and imagined to be placed in another multi-dimensional whole. Through this, a plane of many dimensions is travelling in any direction to detect the changes. Here again the traversal is shown with cubes in some path. This is the path of knowing the knowledge and can traverse any direction with respect to the reference which is the first cube.

In this perspective, we can see the concept of "perishable" and "imperishable." The underlying properties of the knowledge remains imperishable, irrespective of how many or the direction in which the plane of awareness traverses through this maze. As the plane traverses through this maze, detecting one change then next, the previously detected changes are reconciled into the reference and has perished.

In the above figure, we see that each cube along the path of awareness is perceiving the properties of knowledge at that point and detecting the change in properties between that point and the reference. This is perception. In the above figure, we have created a discrete detection. In nature as we know, everything is analogous, not discrete. So, the change

detection should also be fuzzy as opposed to discrete blocks as we have drawn. In this case we will have a distribution of perception which ends in a fuzzy perception spanning an area of change. This fuzziness of extending the change detection becomes anticipation. As we know, anticipation is always an extension to things we already know and we cannot anticipate the unknown. See figure below:

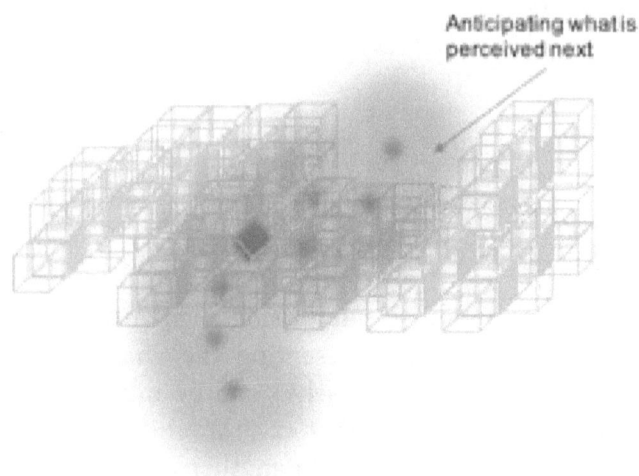

Figure 10: Fuzzy Change Detection as Opposed to Discrete Detection

Awareness is not just of perception. It is also about action. If we overlaid distribution of awareness over the co-ordinate system of knowledge of the environment, we can explain perception of awareness. How do we explain action?

yaavatsaMjaayatE kiMchitsattvaM sthaavarajangamam |
kShEtrakShEtragnyasaMyOgaattadviddhi bharatarShabha ||26||
samaM sarvEShu bhootEShu tiShThantaM paramESvaram |
vinaSyatsvavinaSyantaM yaH paSyati sa paSyati ||27||
samaM paSyanthi sarvatra samavasthitameeSvaram |
na hinastyaatmanaatmaanaM tatO yaati paraaM gatim ||28||
prakRutyaiva cha karmaaNi kriyamaaNaani sarvaSaH |
yaH paSyati tathaatmaanamakartaaraM sa paSyati ||29||

Translation:

That, conquering a part of the true essence of not moving and moving in conjunction with environment and knowledge of environment, is perforation

Equally, each and every that has become, abiding in the primary potential, ended or not ended, what is perceived will be perceived

Equally perceiving in everything, equal standing potential, non-destructive self of selves perishes when the ultimate goal is reached

Also, the nature of the become is, while doing each and every action, it also perceives the non-action of the self

Here, what is talked about is perforation and not perception. There is a difference between perforation and perception. Perforation is where awareness is affecting the knowledge of the environment. We need to remember that the environment that we are talking about contains the void, that which is becoming and that which has already become. Awareness, while we have drawn it in our graphs as a separate dimension and it gives the perception that it is isolated from the environment, we need to remember that it is not. As we will see in the subsequent chapter, awareness can also be considered as a "knowledge of the environment," with a second dimension.

With this in mind, to understand action, we need to understand the concept of *infinite recursion*, which I have addressed in the next chapter (Infinite recursion). Every interaction in the environment is an infinite recursion. The interacting pieces typically affect each other infinitely, before finally settling into an equilibrium state. For e.g., in the battery system of electrodes in a solvent, a final is voltage is settled at. The copper and metal oxide taking on the appropriate ions can be considered as the change exerted by them on the environment around them, which is exactly similar to what we call action.

Just because we consciously go through the individual steps of "understanding, synapses firing, nerves triggering, action done," it does not make the scenario different from just seeing the final result namely, voltage that develops across two electrodes. An action can be considered as a *re-arrangement of the equilibrium of the environment* taking into consideration the motion property of the "knowing of the knowledge of the environment."

The Fuzzy Environment

We see the environment that emerges is not really a static environment, but a fuzzy environment, whose properties are not "set," but varies based on the action of the awareness.

> yadaa bhootapRuthagbhaavamEkasthamanupaSyati |
> tata Eva cha vistaaraM brahma saMpadyatE tadaa ||30||
> anaaditvaannirguNatvaatparamaatmaayamavyayaH |
> SareerasthOpi kauntEya na karOti na lipyatE ||31||
> yathaa sarvagataM saukShmyaadaakaaSaM nOpalipyatE |
> sarvatraavasthitO dEhE tathaatmaa nOpalipyatE ||32||
> yathaa prakaaSayatyEkaH kRutsnaM lOkamimaM raviH |
> kShEtraM kShEtree tathaa kRutsnaM prakaaSayati bhaarata ||33||
> kShEtrakShEtragnyayOrEvamantaraM gnyaanachakShuShaa |
> bhootaprakRutimOkShaM cha yE viduryaanti tE param ||34||

Translation:

If the become, bought about separately is perceived together, then the creation of extension of this expansion happens

That primary self is without a beginning, without a quality and imperishable, the insignificant body does not act nor proliferate

If each and every subtle space has not proliferated, each and every determinate self-body does not proliferate

If the one that controls the light of the entire world is visible, then, the entire environment and that of the environment is visible

If the difference between the environment and the knowledge of the environment is perceived free from the become and the nature of the become, he is held as the prime knower

Previously we had concluded that the environment has to be fuzzy. If the environment is fuzzy, then the environment should take on properties based on the infinite recursion equilibrium as awareness spreads. This verse tells us specifically that as we bring together and perceive multiple becomes, we keep creating and extending the environment we can perceive. We are then looking at something like below:

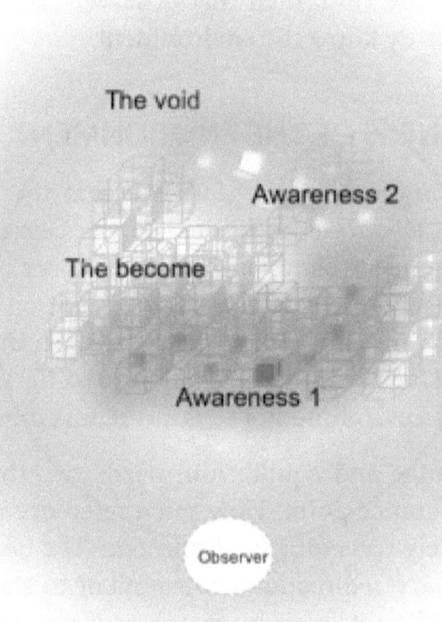

Figure 11: The Fuzzy Environment Where Properties Emerges as Awareness Spreads

Again, while the above shows what the environment seems to the "awareness," the void always remains void and not affected by any of what the awareness is perceiving! To truly understand this, we need to examine the multi-process operating system like Linux. A multi-process operating system can run multiple processes simultaneously, allocating the same amount of memory (say 2GB) and CPU to each and every process. The OS takes care of time slicing, switching between processes by restoring memory, threads, resources and gives the impression of a true multi-processor system. But, here we are not looking at any single program taking care of time slicing, but we are looking at multiple awareness (equivalent to programs) traversing through the same void, but perceiving different things and living different lives. The beauty of

this system is each and every process is self-driven and self-propagating without any mediator between them.

As we were seeing in the section on "Timeless Environment," if we can place an observer in the void, then that observer can see all the parts of this system and can truly know the environment.

LIMITING AWARENESS OF THE ENVIRONMENT

If we look at the sample of battery, we see that the knowledge of the environment for the electrodes is limited to the electrolyte and another electrode within the electrolyte. It does not carry the knowledge of another similar system present in the environment or any other systems present in the environment. So, "knowledge of the enviroment" is inherently limiting. Does a similar limitation exist for the knowing in the secondary redirected environment, i.e., is awareness inherently limiting?

We saw that change and equilibrium needs two things. A secondary redirection and a reference point. How can a reference point be pegged in a multi-aware infinitely spreading environment? The best way to do it is to just limit the secondary redirection environment to start at the reference point and keep extending its own awareness as it progresses, then we have a reference and an awareness existing. Thus awareness needs to be an inherently limiting function.

The theory that seems to be propounded in most of the texts is that the limitation of the knowledge is the reason for discrimination and distinction between various awareness. The Shiva Sutras are purely devoted to explaining this. Intelligence arises purely because of the limitations in knowledge.

<p align="center">Caitanyamatma

jnanam bandhah

yonivargah kalasariram

jnanadhisthanam matrika</p>

Translating:

The intelligent self, limited by knowledge, is the origin of the discriminating indistinct body where knowledge becomes the basis of everything.

Ancient Philosophy ♦ 51

From the translation of the Bhagavad Gita above, we know that knowing is the basis of this whole environment. What is interesting to note here is that this says, limiting this knowledge is the reason for the origin of this discriminating indistinct body. Taking both into consideration, the Bhagavad Gita's learnings and this, an environment emerges where there is a secondary redirection environment with a number of "knowledge of the limited number of knowledge of the environment" which can now be referred to as "an indistinct body of knowledge." One such "indistinct body of knowledge" discriminates from another such "indistinct body of knowledge" and hence becomes the basis of the thought of "I." Thus also is established the "para or remote."

udyamo bhairavah
saktihcakrasandhane visvasamharah
jagratsvapnasusuptabhede turyabhogasambhavah
jnanam jagrat
svapno vikalpah
aviveko mayasausuptam
tritayabhokta viresah
vismayo yogabhumikah

Translating:

Rising of the unmanifested splits the energy cycle and then come together into a universe. Distinguishing between waking, sleep, deep sleep gives the ability to experience Turiya. Knowing is waking state, imagining is dream, absence of illusion is deep sleep. All three experiencing the chief seeking, perplexed, by the part played by the union.

As we will see later, according to the Vijnana Bhairava, the rising of the Prana or Bhairava is the reason for the whole environment to be formed. Once formed, multiple limited awareness are formed within this environment, thus splitting the energy cycle (see formation of the environment for more details) and together forming this universe.

According to this verses, the awareness keeps switching between waking, sleep and deep sleep states, showing that awareness is not stable. I am sure we all can control sleep for some days, but we are always forced to sleep at the end because we become very tired. The troughs and

crests of awareness must be the cause of this. Below, showing a possible threshold which acts as a trigger to switch between states.

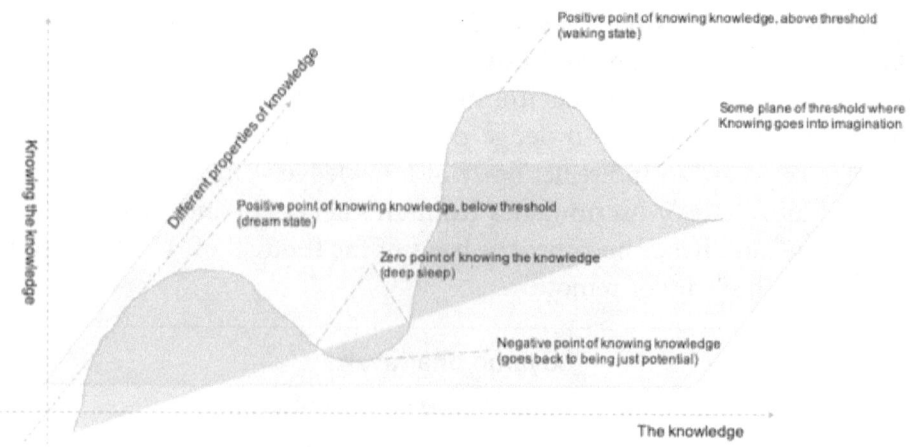

Figure 12: Threshold for Different States

The waxing and waning of knowledge causing various states of existence. When we are in a state of knowing the knowledge of the environment (awareness above a threshold), we are awake, it decays to a point (where it goes below the threshold) where we imagine we know the knowledge of the environment and it becomes a dream, and when this knowing goes down to zero we are in deep sleep. Thus the instability keeps the cycle up of knowing, imagining and not knowing and down to the original environment. This allows us the ability to experience that state where the awareness goes back to just being a nothing, but the original environment with no overlaid layer on it (Turiya). But, it should be noted, that irrespective of which state of being we are in, we are just as perplexed about this whole environment and none of the states have any inherent knowing of the environment or its working.

Peeling the Layers of the Awareness

We seem to live within the confines of this environment. The boundaries defined by the awareness or knowledge of "that which is." The sensory perceptions are always about what has happened or is happening. Thoughts, actions, intelligence, knowledge everything is within this environment. Thus, any actions, conclusions based on sensory perceptions is always going to just traverse a path within this vast environment.

As we saw in the previous chapter, knowledge and knowing this environment has caused awareness of this reality around us. The question then naturally arises "What is this knowledge?," "How is it formed?." As we indicated in the tatvamasi approach, we first start out being the knowledge that we understand. Then the Para Brahma Tattva kicks in and we ask ourselves "Is knowledge the ultimate truth?," the answer turns out to be 'no,' because, there is an *environment of which knowledge* is present. So, we start asking what is the "para" or remote here? How is it formed? How can we see the next in the series?

To move forward, we need to understand "knowledge." The environment seems to be already present. The notion of reality is caused by the change in knowing which starts at some point and keeps detecting

change with reference to the starting point. A depiction of what we are looking for is shown below:

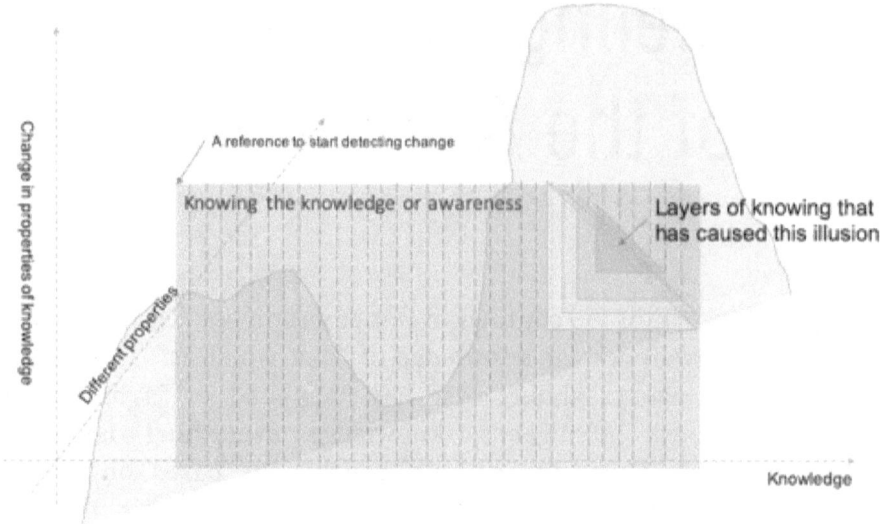

Figure 13: Searching for Layers of Awareness

We need to peel away the layers of "knowing the knowledge of environment." A research into the notion of time should help us understand this. As I had indicated in the "Timeless environment" section, what we see around us can be viewed either as "past, present and future" or "void, become and becoming." Yet, when we read through the Bhagavad Gita's description of environment, we find that time is not real and belongs to the realm of reality, another illusion just like motion or action. Yet, it is not an illusion that can be easily shaken off. It is inherent to the formation of reality around us just like "knowing the knowledge of environment," which indicates that it is tightly tied to knowledge. Hence a study of how time is formed should give us a view into the layers of knowledge.

The Kalabhavirava sthotram and the Maha Kalabhairava sthotrams address this and they definitely seem to point towards the various characteristics of knowledge. We will look at them in-depth to understand awareness.

UNTANGLING AWARENESS

Awareness or knowing the knowledge of the environment can be seen as the most important in this system of reality, for us to exist. So, what is awareness? What are its characteristics? The Kalabhairava Ashtakam describes this very well. On a first look, the kalabhairava Ashtakam talks about the unmanifested that has manifested as time. But, an in-depth look, shows us a totally different picture. So, we will study the Kalabhairava Ashtakam to learn more.

devarAjasevyamAnapAvanAmdhripankjam
vyAlayagnasUtramindukshetharam krupAkaram
nAradAdiyogivrundavanditam digambaram
kAshikApurAdhinAthakAlabhairavam bhaje ||1||

Translation:

The primary energy is produced in pure, unrestrained concentric spheres, overcoming resistance, runs through everything like a blemish mediated by the environment, beginning with the questioning thought that joins together the multitude in plain description, I salute that fist full of time (before and now), owned by the manifested of the time unmanifested.

The Bhagavad Gita talks about primary potential, or maheshwara, while this ashtakam talks about the primary energy or "devaraja." As an aside it should be remembered that "devaraja" is also a term used for "Indra." "Indriya" means sensory, so "Indra" is senses, which means that the "primary energy" was considered to be something which is visible to the senses. So, when the primary potential becomes visible to our senses, it should become devaraja or primary energy.

It is important to note here that the primary energy is produced in "concentric spheres" throughout the environment. We had drawn cubes in our figures previously to depict the awareness, which has only 3 dimensions. An infinite dimension representation is basically a sphere.

So, we needed to have depicted it as spheres instead of cubes. In the below picture I depicted this:

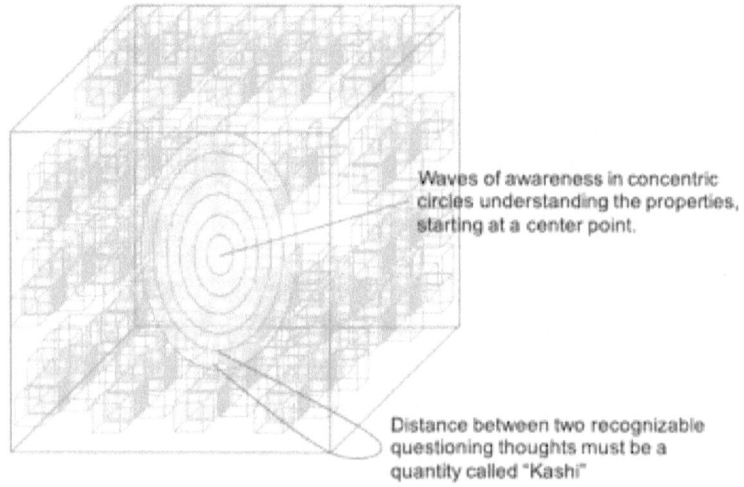

Figure 14: Waves of Awareness as Concentric Spheres

I have retained a cube for the environment, to give it a difference and hence an impact, but that should also be spherical. Also, note, from the previous chapter, that the environment should be fuzzy. Since we are focussing on the part where awareness is spreading, we can be very specific. This is an area which has already formed due to the awareness.

According to the ashtakam, overcoming the resistance in the environment, the knowing is spreading. Again, what is this resistance? Why is there a resistance? More of this in the later verses of this Ashtakam.

The most important point that is taught in this verse is that of the "questioning thought." For e.g., "why is the sky blue?." This is the reason for the growing of the awareness. As questions increase, it grows more. Again the next point to note here is that it does not grow in unrelated circles of knowledge, but is tied together by plain and simple description. It is like creating a very long sentence with a whole lot of connective conjunctions. It goes "the sky is blue because the dispersion of the wavelength of blue is the most in the atmosphere which comes from sunlight which hits the earth from the sun which produces light because of fusion of helium and hydrogen…" and so and so forth it keeps going, connecting various properties to extend.

The concentric spheres grow with analogous continuity as awareness goes from one knowledge to the next. The difference between two consciously recognized awareness must be the quantity called "Kashi." This now gives us a definition of what is past and what is present.

In the modern world's understanding of past, present and future, we cannot draw a line between when the past ends and the present starts or when the present ends and the future starts. These lines are very fuzzy. The past, present and future always seem to merge. By artificially creating a time concept devoid of any relation to reality, (in-fact in relation to an arbitrary reference), such as "second" or "millisecond" or "nanosecond," we can keep defining smaller time slice infinitely because time is as analogous as space. Yet, we cannot accurately define what is "present" and what is "past" with these concepts. Before we realize it, we are in the future, and the present has become a past.

But, changing the view to "void, becoming, become" we can accurately define a duration when we know the properties of the nature of become has changed. This difference between two distinct awareness of change in property is what is recognized as a quantity called "kashi." In this case, the previous awareness of change in property is "pura" and "the current awareness of change in property" is "adi." This now becomes the manifested version of "time." Even though this is as illusionary as awareness, since it is closely tied to what we call reality, it disappears only when the illusion of reality disappears.

bhAnukotibhasvaraM bhavAbdhitArakaM paraM
nIlakaNTamIpsitArthadAyakaM trilocanam
kalakalamMbujAkshashUlamaksharaM
kAshikApuradhinAthakAlabhairavam bhaje ||2||

Translation:

Multiple appearances glisten in the real-world, letting loose the remote. Dark noise causes impulse giving three dimensional awareness. Time and again the imperishable obtains density and is born in ambU. Fist full of time owned by the manifestation of time unmanifested.

What is revealed here is that "awareness" or "purushah" or "soul of the becoming" that we were learning about in the previous chapter is actually

"three dimensional" and not just a single dimension of "knowledge." It is a combination of three dimensions that form awareness. What are the three dimensions? The Kaivalya Upanishad also says something similar:

> umā-sahāyaṃ parameśvaraṃ prabhuṃ
> trilocanaṃ nīlakaṇṭhaṃ praśāntam
> dhyātvā munir gacchati bhūta-yoniṃ
> samasta-sākṣiṃ tamasaḥ parastāt

Translation:

With the help of tranquillity, the prime potential is eternal, the three dimensional awareness and dark noise is silent. By focussed impulse it goes towards the origin of the become, all is witnessed by the stillness beyond.

As we saw in the previous chapter, the environment by itself is non-changing and eternally present, which is what the first line here is saying. By being tranquil, the prime potential is eternal. Something like this:

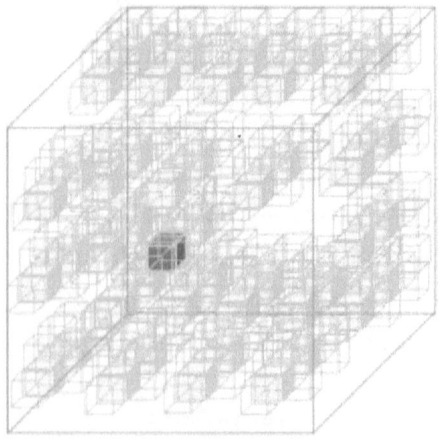

Figure 15: Tranquil knowledge with Impulse

An environment, that has potential, that has a set of distributed properties that is distributed across the environment and with infinite dimensions.

In this, a dark noise or disturbance occurs without the trigger of light, but inherently occurs which triggers a focussed impulse which becomes the origin of our concentric spheres.

Once the impulse is started, we come to the "plane of knowing" that we were learning in the previous chapter. For such a plane to exist, there needs to be *"an environment," "a knowledge of the environment"* and *"knowing of the knowledge of the environment."* This is now the three dimensions in which awareness exists. Thus it says, "nilakaNTa ipsitartha dAyakam trilocanam" or "dark noise causing impulse gives rise to three dimensional awareness."

Another significant reference in this verse, is the reference to *"density."* While we are searching for what knowledge is composed of, this verse tells us plainly what it could be. It says that it is due to the *"imperishable acquiring density,"* the imperishable born. According to the previous line in this verse, the impulse originated the three awareness which is equivalent to birth. From this, it shows that density should be one of the properties that varies in this environment. Many works of literature refer to **sthUla or density as the reason of awareness**. I wonder if it is just density or more properties are combined. But most of the works of literature mention only density.

A more curious question is density of what? Given what we know, the only answer to that question can be "knowledge of environment." "Density of knowledge of the environment" varies across the environment which can be detected. It should be noted, that density of knowledge of the environment is different from strength of awareness. Density seems to be an inherent working associated with detection of knowledge of the environment, while strength is the certainty with which the density is detected. See below:

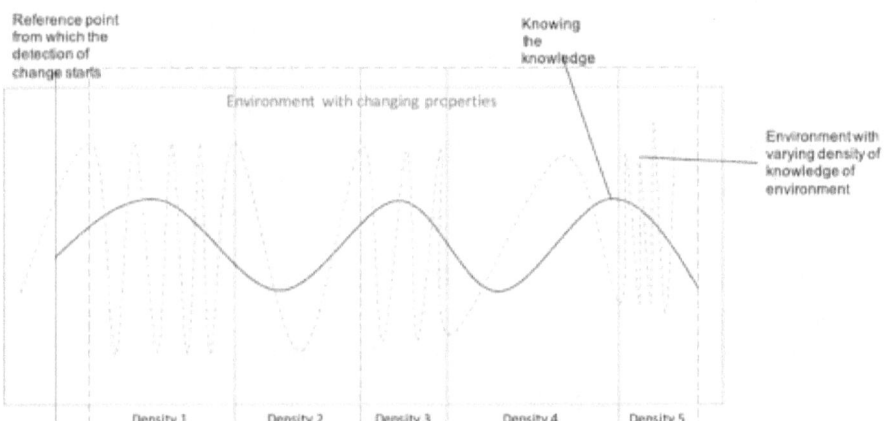

Figure 16: Cross-Sectional View of the Varying Density at the Concentric Spheres

If "knowing the knowledge of the environment" or awareness is in waves of concentric spheres and the "knowledge of the environment" is changing density, then as the wave travels through this changing density, properties of the wave is going to be inherently modified based on the "knowledge of the environment." This is similar to the electrode example that we were talking about for "knowledge of the environment." ***This means for the concentric sphere that we are talking about, "knowledge of the environment" is the same as "knowing of the knowledge of the environment" or "awareness."***

This leads us to an interesting conclusion. If we had an environment of some field (for lack of another word) throughout which the density of the field is changing in some pattern, the field inherently knows how to change density which is "knowledge of the environment." As we saw in the example, if we place carbon and metal oxide electrodes in an organic solvent with lithium salt, carbon takes on negative charge and metal oxide positive charge which is knowledge of the environment. This can be considered as just an appropriate reaction in the density of the field. But, if we had an overlapping field that varies based on the state of this field, which is the concentric waves, then the inherent "knowledge of the environment" for the concentric waves also becomes "knowing the knowledge of the environment."

The Shiva Tandava sthotram says: "Kishore Chandra kshetere prati kshanam mama" meaning "the environment of direct and reflected light is present in each and every I." This could explain the formation of the dark noise. If there was direct and reflected fields with obvious change in phase, we are looking at two overlapping fields that is required for knowing the knowledge of the environment. More about this in the next chapter.

shUlaTangkapAshadaNDapANimAdikAraNaM
shyAmakAyamAdidevamaksharam nirAmayam
bhImavikramaM prabhuM vichitratANdavapriyaM
kAshikApuradhinAthakAlabhairavam bhaje ||3||

Translation:

Binding density to the void causes the beginning of existence of force. In the beginning where the imperishable is pure, the multitude energies are equal. When tremendous motion is associated with this equal energies abundant variety of agitation is generated. A fist full of time owned by the manifested of the time unmanifested.

Another illuminating verse. There is an environment with changing density of knowledge, there is another overlaid on it which is a concentric spheres or waves. How is this affected by the changing density? Below, I have shown a sample effect:

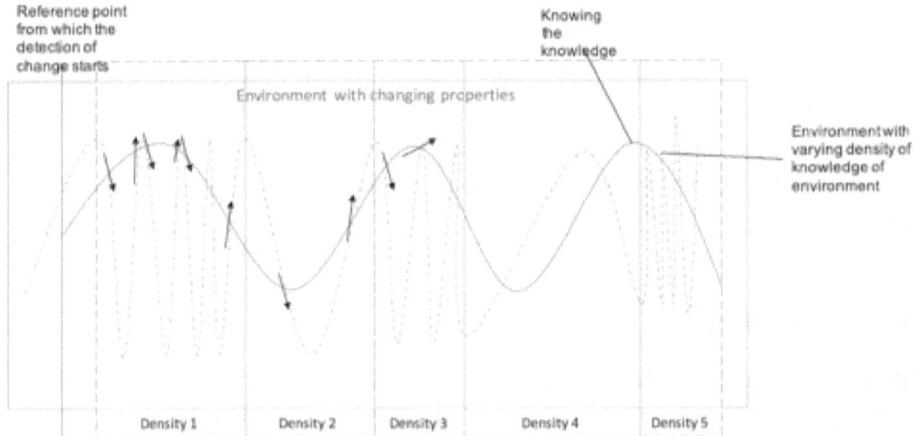

Figure 17: A Cross-Section of the Impact of the Density on the Concentric Spheres

Basically, what we find is that "knowing of the knowledge" really means detecting the effect, which turns out to be *force or resistance the density exerts on the wave* as the wave increases. Thus, by binding a density to the void, we have caused the beginning of *existence of force*. Force brings with it energy. When we first start out at the beginning of the impulse, i.e., at the reference point or the centre of the sphere, the knowing of the knowledge of the environment is pristine and unaffected by the environment. But as it travels in concentric spheres, more and more of the effect of the density change, affects it and creates a huge variety of agitation. Question to be asked is, how is it that the environment and knowledge of the environment affects the awareness, but not the other way round?

<div style="text-align:center">
bhuktimuktidAyakaM prSastachAruvigrahaM

bhaktavatsalaM sthitaM samastalokavigraham

viniksaNanmanognahemakinngkiNilasatkaTiM

kAshikApuradhinAthakAlabhairavam bhaje ||4||
</div>

Translation:

Limiting freedom gives comfortable form. In its assigned affinity form, the whole world is situated, every instant pleasant impulse playing encompassed by the buzzing. A fist full of time owned by the manifested of the time unmanifested.

The next illuminating point here. While we can have the concentric spheres grow infinitely, by limiting it we have started having a comfortable form. This verse also answers the question that arose in previously as to why is it the knowledge of environment affects the awareness, but not the other way round?

Infinite Recursion

The answer lies in understanding the infinite recursion in nature. Infinite recursion is the reason for nature to seem so analogous, in some places this is also referred to as the positive feedback system. The alternate is a negative feedback system. In a negative feedback system, the feedback that occurs from the output of a system to the input of a system tends to reduce the output of the system, so that progressively it can take on a stable value and remain there. A mono-stable circuit can be considered as a negative feedback system. If the circuit is tripped to take on a voltage, it decreases down to the zero value and stays there. In a positive feedback system, the feedback that occurs from the output of the system to the input of the system tends to increase the output of the system, thus producing an unstable condition. An oscillator is an example of a positive feedback system. An oscillator is a controlled feedback, consciously added to create an oscillator.

In nature though, positive feedback occurs uncontrolled. The best example of this can be seen when we place the microphone whose input we are recording very close to the playback speakers of the same recorded voice. An example of a positive feedback loop can be seen here. What happens here is, the voice output of the speaker also gets recorded and gets played back along with the voice input to the microphone. This boosts the voice in the speaker which again is picked up by the microphone and the cycle continues going into an infinite recursion. Yet unlike our computers it does not throw a stack overflow exception, but settles into a comfortable screeching noise which is a combination of all the echo and voice.

For another e.g., let's take wind blowing. The molecules of air at one location has to exert a force on the molecules at the adjacent location. Now the molecules in the adjacent has to exert a force back on the current location molecules, which causes the agitation in the current molecules to increase which then increases force exerted on the adjacent molecules which again has to push back on these molecules with higher force and so on so forth it keeps goes. Yet, we find that it stabilizes at a comfortable force between the two molecules as if on consensus without a problem, due to which the wind blows in one direction versus the other.

Another example is the very famous infinite resistor circuit problem.

Figure 18: Circuit of Infinite Resistors

While the circuit seems unsolvable, it is solved by first terminating the infinite series with a single resistor and calculating the resistance. What is surprising is that the resistance turns out to be the same as the resistance that we have terminated with i.e., 'R.'

Just like the infinite recursion, the system comes into a balance at a certain point, the circuit seems to come to a balance at a certain terminated resistance, in this case it is 'R.'

This goes to show that just adding infinite resistors in series and parallel does not cause the resistance to become infinite in real world. It always settles at a comfortable agreed upon value and stays there, this is equilibrium.

Equilibrium

Similarly, in our case, it is not that there is no effect of the "awareness" on the "knowledge of the environment." It is just that a comfortable form is settled at, when we detect the density. This is what is called as equilibrium in the chapter 13 of Bhagavad Gita and here it is called "comfortable form." See below:

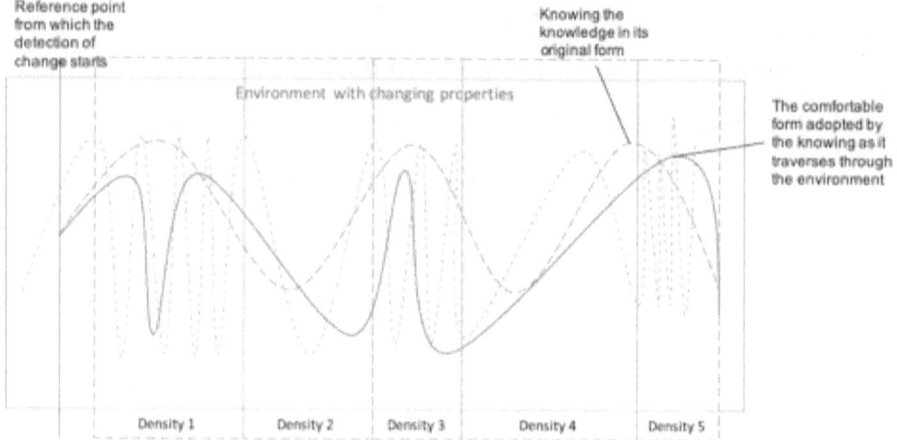

Figure 19: A representation of the Comfortable Form

The comfortable form is taken on and is determined by what affinity the concentric spheres have to the knowledge buzzing around them.

dharmasetupAlakaM tvadharmamArganAshakam
karmapAshamocakaM susharmadAyakaM vibhum
svarNavarNasheShapAshashobhitAngamaNDalaM
kAshikapuradhinAthakAlabhairavam bhaje ||5||
ratnapAdukAprabhAbhirAmapAdayugmakaM
nityamadvitIyamiShTadaivatam niranjanam
mrtyudarpanAshanaM karAladaMShTramokshaNaM
kAshikapuradhinAthakAlabhairavam bhaje ||6||

Translation:

Following the bound affinity, removing the path of other affinities, freedom from that bond by action gives protection to the all-pervading. Self-description and description of the rest, forms the part of the circle of a fist full of time owned by the manifested of the time unmanifested

Beautiful radiance from the valuable base joined at the base, continuously situated in pure energy kindling the perishable, freeing from immense tentacles of a fist full of time owned by the manifested of the unmanifested

The effects of the awareness on the environment is explained here. The reference point of the awareness is something that has tied it down, while the rest is flexible, whereas the environment in which it moves is not so, as we saw, it is a fuzzy environment. The knowing has more flexibility than the environment of knowledge in which it is moving. Thus, the path of least resistance is where the awareness adjusts as opposed to the environment of knowledge adjusting. Again as we saw in the previous chapter, while action of awareness seems to the awareness as if it is affecting the environment, in actual, it is also taken into consideration when the equilibrium is arrived at.

Rationalization

The density detection that is happening is analogous. But, we are only aware periodically at an interval of what we had previously defined as "kashi" which then goes on to uniquely define past and present. How does this rationalization occur between the analogous detection and time awareness? This is explained in these last verses of Kalabhairava Ashtakam

aTTahAsabhinnapadmajANDskoshasaMtatiM
druShTipAtanaShTapApajAlamugrashAsanam
aShTasiddhidAyakaM kapAlamAlikAdharaM
kAshikapuradhinAthakAlabhairavam bhaje ||7||
bhUtasaMghanAyakaM vishAlakIrtidAyakaM
kAshivasalokapuNyapApashodhakaM vibhum
nItimArgakovidaM purAtanaM jagatpathiM
kAshikapuradhinAthakAlabhairavam bhaje ||8||

Translation:

Vibrant buoyancy breaks the concentric spheres into a line of animal containers. Loss of wisdom, falling into the trap of imperfect, inflexible order. Obtaining understanding gives this multitude lines a thread through a fist full of time owned by the manifested of the time unmanifested

The past becomes the guide giving extensive recollection. A fist full of living in pure world, the imperishable corrects the imperfect guiding in the path of knowing. The ancient owner of this world, a fist full of time owned by the manifested of the time unmanifested

These verses reminds me of digitization of analogous signals. To do so, we sample the analogous signal and assign 1 and 0 to the sampled signal based on whether their amplitude is above or below a threshold. We have forced the analogous signal into an arbitrary order, by giving up knowledge of amplitude.

Imagine, if the same is done based on frequency instead of amplitude. We sample the frequency changes and assign to it various data points based on some threshold. We have forced an analogous series of data points into a set of inflexible order, by giving up information. Once, we have done this, we need to tie all of them together in some form, which is like tying them together in a string.

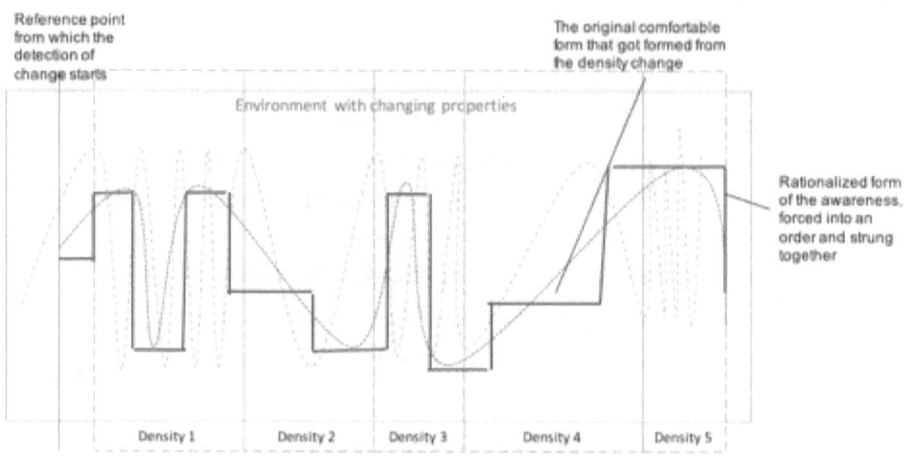

Figure 20: Rationalization

Rationalization is applied over the analogous detection of density change and each of the values fit into a certain container for understanding by the brain and then strung together to give understanding finally. Here, obviously the past becomes the guide to understand and rationalize.

Equilibrium, Change and Rationalization

We learnt that the knowing of the knowledge of environment or awareness spreads in waves of concentric spheres.

Dark noise originates an impulse that starts off the concentric circles of awareness. Awareness has three dimensions, the environment, the knowledge of the environment and the knowing of the knowledge of the environment. This associates a density to the environment of knowledge.

This density association has caused force to be created.

The awareness has settled onto a comfortable form by limiting the freedom and taking on an affinity.

Over which we apply rationalization to form this reality around us.

LAYERS OF AWARENESS

The Kalabhairava Ashtakam showed us the dimensions needed to form knowledge, it talks about the density that causes the knowledge detection possible and also talks about the various effects of the density associated to the void. But does not talk about how this knowledge translates into this spirit or reality that we experience. This is what is told in the Maha Kalabhairava sthotram. The Maha kalabhairava sthotram lists a sequence of layers that take you from awareness to the edge of this environment.

Definitely, the layers can be talked about as layers followed through for a single awareness. But, in this case we will miss out the implications of the interactions between various awareness that happens. This sthotram is best understood when looked at as layers present across all individual awareness present in this environment.

We can read this sthotram top-down or bottom-up. Both have meaning. I have followed the bottoms-up approach here, since it gives us a very good continuity from what we have been reading about, so we follow up from the "knowing of the knowledge" upward till we reach the spirit.

Bhrum Bhrum Bhrum Bhootanadham, Pranmata Satatam, BHAIRAVAM KSHETRA PAALAM ||8||

Tam Tam Tankaara nadham, Trida salata la tam, Kaama Garvaapa Haram

Dham Dham Dham Netra roopam, Siramakuta Jataabandha Bandhaagra Hastam

Ham Ham Ham Hamsa Haasam, HasitakalaHakam, MuktaYogaattahaasam

Roum Roum Roum Roudra Roopam, Pranmata Satatam, BHAIRAVAM KSHETRA PAALAM ||7||

Aim Aim Aim Aishwarya Naadham, Satata Bhayaharam, PoorvaDeva Swaroopam

Pam Pam Pam Padmanabham, HariHara Mayanam, Chandra SuryaAgni Netram

Sam Sam Sam Siddhi Yogam, Sakala guNa Ghanam, Deva Devam Prasannam

Vam Vam Vam Vaala Leelam, Pranmata Satatam, BHAIRAVAM KSHETRA PAALAM ||6||

Houm Houm HoumKaara Nadam, Prakatita Gahanam Garjitairbhoomi Kampam

Ksham Ksham Ksham Kshipra Vegam, Daha Daha Dahanam, Tapta Sandeepya Maanam

Kham Kham Kham Khadga Bhedam, Visha Mamruta Mayam Kaala Kaalam Karalam

Am Am Am Aantariksham, Pranmata Satatam, BHAIRAVAM KSHETRA PAALAM ||5||

Yam Yam Yam Bhootanadham, Kili Kili Kilitam Vaalakeli Pradhanam

Mam Mam Mam Mam Mahaantam, Kula makula kulam Mantra Guptam Sunityam

Sham Sham Sham Shankha Hastam, Sashi kara dhavalam, Moksha Sampoorna Tejam

Translation:

Bhrum is the reverberation of the past

Tam the humming noise of three-dimensions giving rise to disturbance of self-interest

Dham is the guidance form from the forehead that is tied down at the entanglement

Ham is the instability of the universal soul transcending the indistinct sound, freely harnessing the buoyant vibrancy

Roum is the fierce form

Aim is the omniscience continuous noise present dispersing perturbations before energy is formed

Pam is the centre of the concentric spheres of illusion establishing and destroying equilibrium, guide of direct and reflected light

Sam is the harnessing of knowledge of the dense quality of the entire pure energy and energies

Vam is the beauty of those bristles

Houm is the roaring noise of the dense manifested roaring matter in motion

ksham is the agile speed of destroying the heated kindled thoughts

kham is the differentiating between the disturbances causing the illusion of changing and the unchanging and hence this immense time

Am is the intermediate region

Yam is the noise of the past tied together in bristles destroying

Mam is the dense collection of unopened accumulation, a design constantly moving

Sham is the measure of uncertainty in the white beam of light freeing the entire entropy

The below diagram indicates the various layers as you go from the underlying density perception upward as described in the verses above. We start with the layer of reverberation of the past, since this is the layer in which we saw the environment, where awareness has caused formation of the become (which turns out to be the past) and a fuzzy becoming.

Figure 21: The Layers from the Reverberation of Past to Uncertainty

The reverberation of past causes a humming noise giving rise to three dimensions which we saw to be "the environment," "the knowledge of the environment" and "the knowing of the environment," which causes a disturbance causing "self." This disturbance is guided by the vibration from the forehead tied at the entanglement (this we will see in the next chapter on formation of the environment), causing an instability in the universal soul allowing it to freely harness the buoyant vibrancy giving us "Roum" the fierce form.

This fierce form has a omniscience continuous noise that is dispersing perturbations, some of these perturbations starts off the concentric spheres that establish and destroy the equilibrium in that environment of direct and reflected light (again will be seen in the next chapter as to where this comes from), which allows the detection of the density of all the energies that are formed giving us "Vam" the bristles.

These bristles when in motion, cause the formation of matter in which heat is created and destroyed kindling thoughts, allowing for the recognition of the difference between the disturbances which are perishable and the underlying imperishable causing time, thus giving us the intermediate region.

In this intermediate region the noise of the past tied together using the bristles is destroyed releasing the dense collection of unopened accumulation in that bundle freeing entropy and hence causing uncertainty in the beam giving rise to the illusionary image.

Mam Mam Mam maayi roopam Pranmata Satatam BHAIRAVAM KSHETRA PAALAM ||4||
Cham Cham Cham Cham chalitvaa chala chala chalita chchaalitam bhoomi chakram
Kham Kham Kham khadga hastam tribhuvana nilayam bhaskaram bheema roopam
Vam Vam Vam vaayuvegam natajana dayinam Brahma paaram param tam
Nam Nam Nam Nagnaroopam, Pranmata Satatam, BHAIRAVAM KSHETRA PAALAM ||3||
Rum Rum Rum Roondamalam, ravi tama niyatam taamra netram karaalam
Dhoom Dhoom Dhoom Dhoomra Varnam Sphuta vikata mukham Bhaskaram Bheemaroopam
Lam Lam Lam Lam Vadantam la la la la Lalitam Dheergha Jivhaa Karaalam
Tam Tam Tam divya Deham, Pranmata Satatam, BHAIRAVAM KSHETRA PAALAM ||2||
Kam Kam Kam Kaala Paasham Dhruka Dhruka Dhrukitam Jwaalitam Kaamadaaham
Gham Gham Gham Ghosha Ghosham Gha Gha Gha Gha Ghatitam Ghargharam Ghora naadam
Ram Ram Ram Raktavarnam, Kata katitam Teekshna Danstraa Karaalam
Pam Pam Pam Paap Naasham Pranmata Satatam BHAIRAVAM KSHETRA PAALAM ||1||
Dam Dam Dam Deergha Kaayam Vikruta Nakha Mukham Hyurdhva romam Karaalam
Sam Sam Samhaara Murtim Shira Mukuta Jataa Shekharam Chandra Bimbam
Yam Yam Yam Yaksha Roopam Dasha Dishi Viditam Bhoomi Kampaayamaanam

Translation:

Mam is the illusionary form

Cham is the agitated tremulous motion of the circle of matter

kham is the measure of disturbance in the three worlds resting in shining fierce form

vam is the speed of breath producing movement causing creation crossing later fading away

Nam is the naked form

Rum is the immense strings of light residing in the darkness

Dhoom is the need to describe with clarity the obscure fierce form of light

Lam is the description of delight by the immense need of the mouth

Tam is the indistinct body

Kam is the trap of time that supports the fire of thirst of desire

Gham is the deep sound that causes the noise that causes the terrible tune

Ram is the description of the adhesion that causes the immense heat distribution map

Pam is the destruction of the imperfection,

Dam is the deep changing fierce face of the immense void in the heart

Sam is the form collected at the tip of the head, an entangled mass of reflected light

Yam is the spirit form that knows the 10 directions and enjoys the comfort of matter

The below diagram shows the layers from the illusionary form to the spirit as indicated by the verses above:

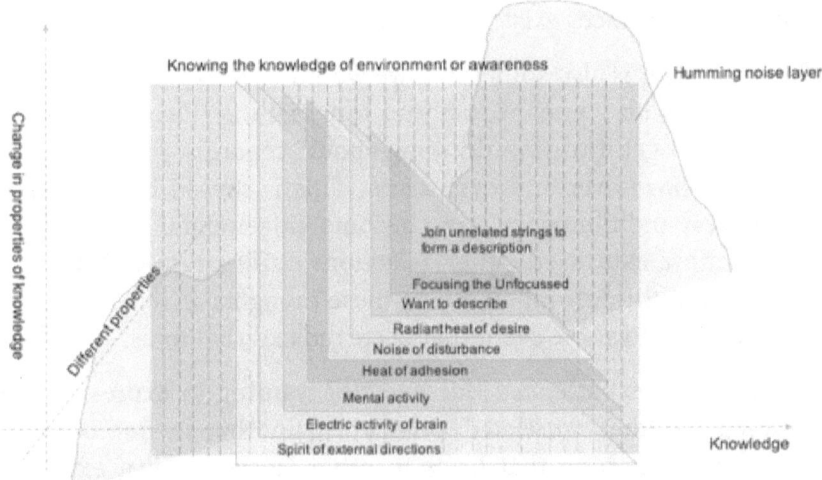

Figure 22: The Detailed Layers from the Illusionary form to the Spirit

This illusionary image supports the tremulous motion of matter causing disturbance in the three worlds (this should be the environment, the knowledge and the knowing of the knowledge), causing motion that creates and fades giving us the first naked form of a sense of reality as we know it.

In this naked form of reality we see strings that we start connecting together to create a clear picture from obscure strings causing the need for us to describe what we have connected together, this giving us the first version of the body.

This indistinct body is trapped in time (which is a recognition of the difference between perishable and imperishable) which supports attachment which then causes noise producing heat forming a heat map which then starts giving us a imperfect environment.

In this immense imperfect environment we see the fierce face of the mental activity, which causes our brain at the top of the head to start functioning causing a spirit to be formed that enjoys matters and the outside world.

We have to recognize that we seem to have explored nothing beyond the mental activity layer. We may have inadvertently experienced the layer of heat, noise and desire and thus experienced the indistinct body without actually realizing it.

When we are embarrassed, we have adrenaline running in the blood stream or any such scenarios, we would have experienced the heat layer that causes the emotions. Goosebumps, chills down the spine due to fear and many such instances exist where this layer comes to the fore.

The noise layer is also something we would have experienced when we are angry, livid with someone, we find our brain is filled with nonsense and we just can't get it to stop thinking about scenarios, points to support our idea and so on over and over again. This is caused by the noise the surfaces as heat and then goes on to become judgemental and then visible thoughts that are expressed either as actions or suppressed. Yet, we have never stopped to think from where do these thoughts arise, and just brush it off as a reaction to some event that occurred external to us.

We may have experienced the layers of wanting to express ourselves by stringing together unrelated points. Again this is not consciously recognized as something that leads to other layers but just experienced in dire situations sometimes, when we tend to connect the dots to come up with an answer. None of the other layers are consciously seen. They work underneath seamlessly and without a focussed meditation it is not be possible for us to experience it.

Every verse seems to stop at a level where something discernible is formed. In conclusion, according to this, these 8 levels should be distinctly recognizable in the awareness we have:

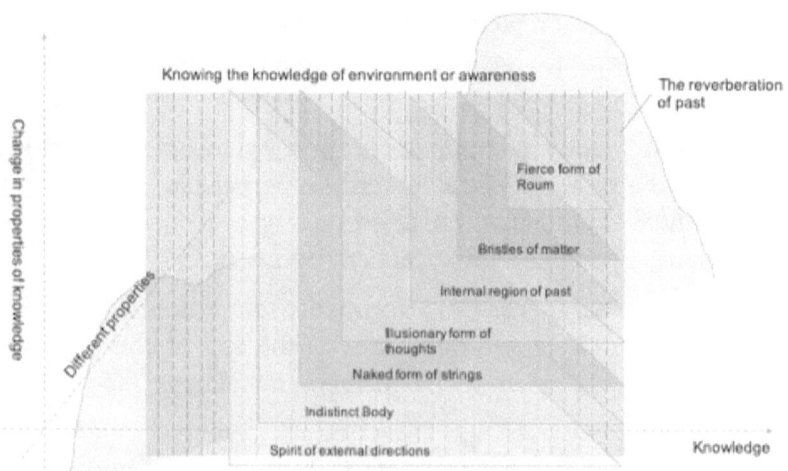

Figure 23: Different Levels the Awareness goes Through Before Being Aware of the External

Manifestation of the Environment

In the previous chapters we understood the environment that we are in, we understood the second layer of awareness that is overlaid on this environment to cause the existence of sentience. We saw the various dimensions, properties and layers of this awareness.

The question that arises is, how is this environment even formed? What is beyond this environment which triggers the formation of such an environment? Is this the only such environment or can they possibly be other such environments?

The Shiva Tandava sthotram is typically associated with the dancing form of Shiva. Shiva Tandava is said to be the dance of creation. So a in-depth study of this sthotram should lead us to understand creation.

FORMATION OF THE ENVIRONMENT

As we saw, the Maha Kalabhairava sthotram started from the outer spirit that enjoys matter as we know it and traced the path all the way down in layers of awareness to that which had become. The Shiva Tandava sthotram approaches this same environment from the opposite side.

Jatta-Attavii-Galaj-Jala-Pravaaha-Paavita-Sthale
Gale-valambya Lambitaam Bhujangga-Tungga-Maalikaam |
Ddamadd-Ddamadd-Ddamadd-Ddaman-Ninaadavadd-Ddamar-Vayam
Cakaara Canndda-Taannddavam Tanotu Nah Shivah Shivam ||1||
Jattaa-Kattaaha-Sambhrama-Bhraman-Nilimpa-Nirjharii
Vilola-Viici-Vallarii-Viraajamaana-Muurdhani |
Dhagad-Dhagad-Dhagaj-Jvalal-Lalaatta-Patttta-Paavake
Kishora-Candra-kshethare Ratih Pratikssannam Mama ||2||

Dharaa-Dharendra-Nandinii-Vilaasa-Bandhu-Bandhura
Sphurad-Diganta-Santati-Pramodamaana-Maanase |
Krpaa-Kattaakssa-Dhorannii-Niruddha-Durdhara-[A]apadi
Kvacid-Digambare Mano Vinodametu Vastuni ||3||

Translation:

Roaming within the entanglement, constricted and subject to frigid temperatures gives us a pure place. Orthogonal to this constriction bends a small series, weaving the resonance of the sound Dam, this tumultuous dancing circle stretching into the shiva's shivam

The entangled hollow, agitating, moving to and fro, super natural cascade, unsteady wave twine seated primarily at once in the front of the cold intersection of pure, having direct and reflected light environment in which is seated every moment of "I"

Supporter supporting senses, increases appearance connecting to the oscillating (wave), vibrating at a remote distance stretching strengthened with the manas, appearance glance (to the entangled) stopped restrained to stand fast, the naked shielded by the manas diverted by reality

The obvious question here is what is this "entanglement" that is being talked about? We need to see this with respect to what we have learnt about the environment previously. If we draw an entanglement as below (I have drawn it as a 2D, but a 3D would have been to take the cube we had and add entanglement to it), also to note, I have created this entanglement with mostly a horizontal direction of travel, it needs to have all directions of travel:

Figure 24: The Entanglement

According to this verse, if we constrict it and subject it to frigid conditions, we should get a pure place. What is pure then? If we are looking at waves, then it should be that the frigid conditions and constriction restricts the type of wave that occupies that constriction. Even if it is not a wave, I assume, the frigidity ensures that only that of the entanglement that match in properties are present in this constriction. I have assumed and drawn waves for easy understanding by the brain. I have depicted in the below diagram what is said in this verses:

Figure 25: Constricted Entanglement Subject to Frigid Conditions

And surprise, surprise, it resembles a damaru or the drum that is usually depicted to be in the hands of Shiva in the Nataraja form or any other form.

Figure 26: Damaru

I wonder if the damaru gave the idea to the researchers about the formation or the formation triggered the creation of damaru instrument. But which ever came first, the resemblance is uncanny.

The bent hanging "series" circles back into the entanglement, thus causing an echo and hence must be the reason for the "resonance."

And it must stretch pretty far, though in comparison to the entanglement, it may not be comparable. I am not sure if it is just a single series that bends or more than one. My take is, that it is more than one, with a central or prime one which stretches the farthest. There are a number of places along the various verses that talks about primary potential or primary energy as we saw. This then must be the primary energy or potential that is being referred to.

Furthermore, because it circles around itself and comes back and meets the entanglement, we are looking at a whole set of direct and reflected waves criss crossing over each other. This is exactly what we found forms the environment that we were talking about. This also reiterates the point, that in this environment of direct and reflected waves, each and every "I" is situated.

Now that it has stretched relatively away from the entanglement, any knowing of the knowledge of environment will be limited and hence not have a chance to look back on the main part from where this whole started. Once the knowing is established, traversing through the various layers of knowledge and awareness as we saw, the manas is established and now it is not stuck enamoured by the things that it has detected around it and not looking back towards the constriction from which it originated.

Jattaa-Bhujangga-Pinggala-Sphurat-Phannaa-Manni-Prabhaa
Kadamba-Kungkuma-Drava-Pralipta-Digvadhuu-Mukhe |
Mada-andha-Sindhura-Sphurat-Tvag-Uttariiya-Medure
Mano Vinodam-Adbhutam Bibhartu Bhuuta-Bhartari ||4||
Sahasra-Locana-Prabhrty-Ashessa-Lekha-Shekhara_
Prasuuna-Dhuuli-Dhorannii Vidhuusara-Angghri-Piittha-Bhuuh |

Bhujangga-Raaja-Maalayaa Nibaddha-Jaatta-Juuttakah
Shriyai Ciraaya Jaayataam Cakora-Bandhu-Shekharah ||5||
Lalaatta-Catvara-Jvalad-Dhanan.jaya-Sphulingga-Bhaa
Nipiita-Pan.ca-Saayakam Naman-Nilimpa-Naayakam |
Sudhaa-Mayuukha-Lekhayaa Viraajamaana-Shekharam
Mahaa-Kapaali-Sampade-Shiro-Jattaalam-Astu Nah ||6||

Translation:

Bent from the entangled the reddish-brown vibration produces jewel like radiance, this multitude reddish brown flowing, smearing to bring forth a direction, that excites the different outer dense dark reddish-brown vibration, the diversion of the excited manas reverberating in the past

The thousand illuminations bringing forward the remaining edges to the peak producing an uninterrupted series of dust, the basis of the root of dust-coloured bend first coming from that series bound into a twisted thicket, vibrancy for a long time has become a circle connecting to the head

At the head a cross-way alight with fire clear linga splendour, imbibed with five arrows bending super-naturally the chief line of lightning ray of light situated at the head, large head is on equal footing with the summit of the entanglement

Pingala, kumkuma and sindura translate to various shades of reddish-brown. My take is these have been used for other materials that resemble these vibrations. Yet, here, these can have only one meaning, a certain frequency of vibration or a certain set of properties of the various properties that exists in the entanglement. Given that red has lesser dispersion and more focus, it needs to be vibration, but that is just a guess work. But if we draw what is being described by these verses, we find we are drawing what is actually called a "Lingam," with the central non-dispersed frequency going the farthest and the rest going shorter and shorter distances before circling back to the intersection of the constriction of the entanglement.

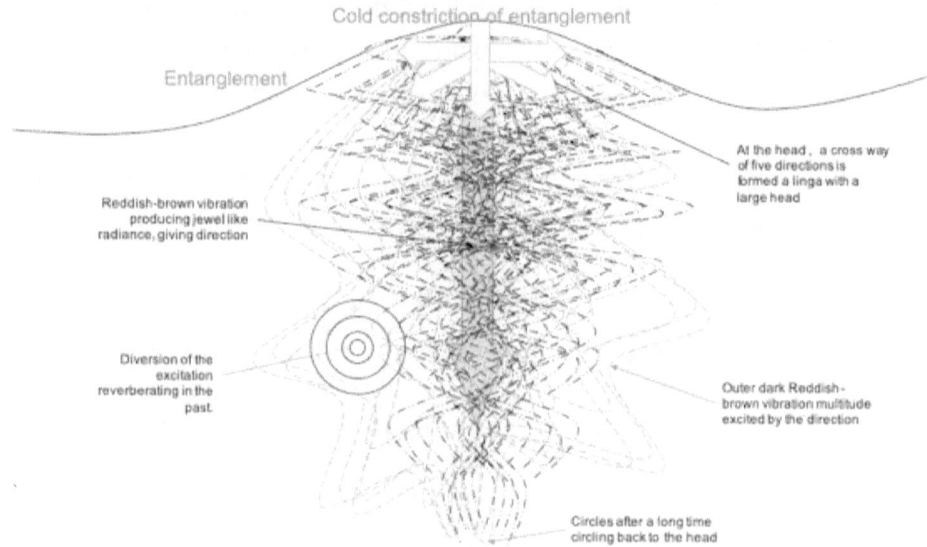

Figure 27: Reddish Brown Vibration Spreading the Farthest, then Turning back to Meet the Entanglement

It is strange that if we look at this diagram, we can either view the Lingam as the base at the constriction and the tip of the Lingam at the farthest point where the vibrations circle back or we can view the Lingam as the connector at the point of constriction and the base being the imaginary line draw to connect the to sides of the un-constricted entanglements in this diagram, obviously in an infinite space this will look like the actual Lingam in the depression space where the entanglement is constricted. I believe what is considered as a Lingam, is the depression space where the entanglement is constricted, since the verse says that it has a large head with an equal footing with the summit of the entanglement.

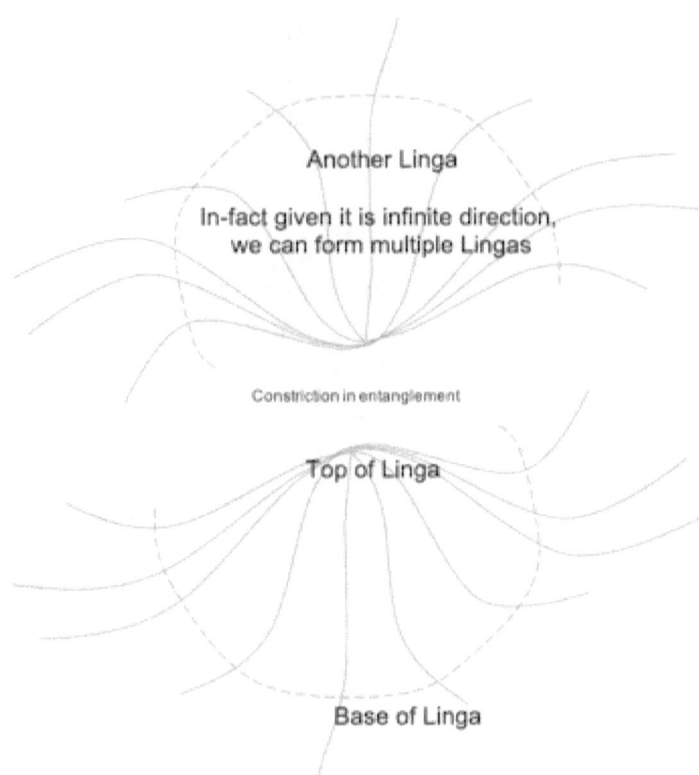

Figure 28: The Lingam in the Constriction of Entanglement

The farthest away, where it turns back we are looking at the environment that we were learning about from all the other literature, an environment where direct and reflected lights merge to form density. At the head or cross way is according to this verse 5 directional, as I have marked in the previous diagram.

Karaala-Bhaala-Pattttikaa-Dhagad-Dhagad-Dhagaj-Jvalad_
Dhanan.jaya-[A]ahutii-Krta-Pracanndda-Pan.ca-Saayake |
Dharaa-Dhare[a-I]ndra-Nandinii-Kucaagra-Citra-Patraka
Prakalpanai-[E]ka-Shilpini Tri-Locane Ratir-Mama ||7||
Naviina-Megha-Mannddalii Niruddha-Durdhara-Sphurat_
Kuhuu-Nishiithinii-Tamah Prabandha-Baddha-Kandharah |
Nilimpa-Nirjharii-Dharas-Tanotu Krtti-Sindhurah
Kalaa-Nidhaana-Bandhurah Shriyam Jagad-Dhurandharah ||8||

Praphulla-Niila-Pangkaja-Prapan.ca-Kaalima-Prabhaa_
[A]Valambi-Kannttha-Kandalii-Ruci-Prabaddha-Kandharam |
Smarac-Chidam Purac-Chidam Bhavac-Chidam Makhac-Chidam
Gajac-Chida-Andhakac-Chidam Tam-Antakac-Chidam Bhaje ||9||

Translation:

The immense band at the head shining at once invoking the violent five directional fire supporting the increase of senses propagating a picture from the bosom to the foremost tip supplying the one sculptor resting in "I"

New conception of circle vibration obstructed by heavy, dark guided connection, bound at the constriction super natural cascade supporting stretching red vibration part preserving and harnessing the oscillation of vibrant world

Expanded dark concentric circles amplifying blackness shine forth orthogonal to the constriction girth splendour tied to the constriction, becomes the division of persistence, body, origin, vigour, length, ignorance and exhaustion

In-fact, if we imagine the Sun with its sun-flares thrown from the surface which bends back towards the sun, that comes near to the best imagination I can think of for this description. Now, imagine this sun flare pulsating. The below picture shows what these verses are talking about:

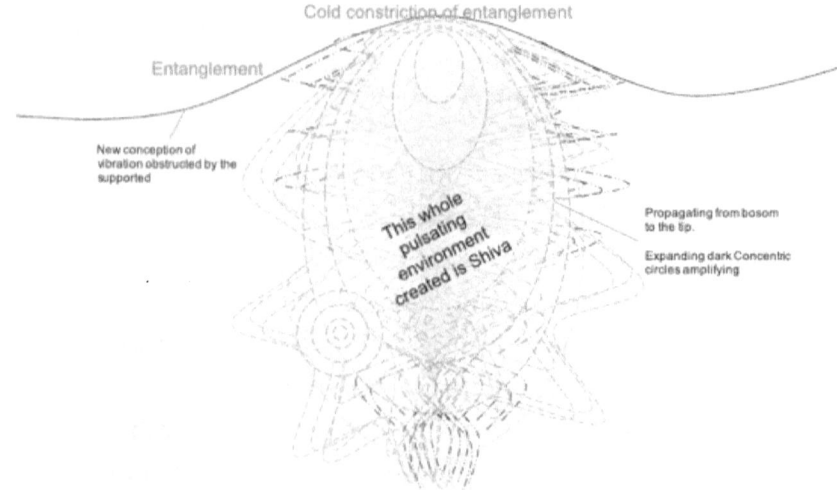

Figure 29: Shiva

This is definitely something that has to be considered that there are two levels of concentric circle vibrations. One starting from the head to the tip pulsating and then there are the small concentric spheres within the environment that form the limited knowing of the knowledge of the environment. So, we are looking at a first limitation from the entanglement that limits the vibrations and a second limitation over this before the knowing is detected.

Akharva-Sarva-Manggalaa-Kalaa-Kadamba-Man.jarii_
Rasa-Pravaaha-Maadhurii-Vijrmbhannaa-Madhu-Vratam |
Smara-Antakam Pura-Antakam Bhava-Antakam Makha-Antakam
Gaja-Antaka-Andhaka-Antakam Tam-Antaka-Antakam Bhaje ||10||
Jayat-Vada-Bhra-Vibhrama-Bhramad-Bhujanggama-Shvasad_
Vinirgamat-Krama-Sphurat-Karaala-Bhaala-Havya-Vaatt |
Dhimid-Dhimid-Dhimidhvanan-Mrdangga-Tungga-Manggala_
Dhvani-Krama-Pravartita-Pracanndda-Taannddavah Shivah ||11||
Drssad-Vicitra-Talpayor-Bhujangga-Mauktika-Srajor
Garissttha-Ratna-Lossttthayoh Suhrd-Vipakssa-Pakssayoh |
Trnna-Aravinda-Cakssussoh Prajaa-Mahii-Mahendrayoh
Sama-Pravrttikah Kadaa Sadaashivam Bhajaamy-Aham ||12||

Translation:

When unmutilated all group cluster together in a continuous series expands, the essence continuing spreading pleasant order will become the end of persistence, body, origin, vigour, measure, ignorance, dullness Excelling description head move about wander in turn flowing to escape from continuous series of immense lustrous vibrations invoked within an enclosure drumming in expansion, the continuous series of noise set in motion by the tumultuous dancing of Shiva

To see various formulated turns set free throwing heavy treasure in heaps well-disposed on all sides, the trifle gaining notice propagating earthen senses equally set in motion is always caused by Shiva

Shiva is basically that dark concentric circle vibration starting at the head and extending to the tip being in continuous series due to the attachment to the entanglement at the tip which is called the tumultuous dance of Shiva.

CONNECTION OF THE ENTANGLEMENT TO THE ENVIRONMENT

As we saw in the Shiva Tandava sthotram the Lingam is formed at the root of the formation of the environment. This acts as the connector between the entanglement and Shiva. The Lingasktakam describes this connector.

Brahma-Muraari-Sura-Aarcita-Linggam Nirmala-Bhaasita-Shobhita-Linggam |
Janmaja-Duhkha-Vinaashaka-Linggam Tat Prannamaami Sadaashiva-Linggam ||1||
Deva-Muni-Pravara-Aarcita-Linggam Kaama-Dahan Karunnaa-Kara-Linggam |
Raavanna-Darpa-Vinaashana-Linggam Tat Prannamaami Sadaashiva-Linggam ||2||
Sarva-Sugandhi-Sulepita-Linggam Buddhi-Vivardhana-Kaaranna-Linggam |
Siddha-Sura-Asura-Vandita-Linggam Tat Prannamaami Sadaashiva-Linggam ||3||
Kanaka-Mahaamanni-Bhuussita-Linggam Phanni-Pati-Vessttita-Shobhita-Linggam |
Dakssa-Su-Yajnya-Vinaashana-Linggam Tat Prannamaami Sadaashiva-Linggam ||4||

Translation:

The churn surrounding, the equilibrium shines through, adorned by purity appearing as lingam, causing the destruction of the difficulty in instigating birth, that, I know as the lingam that is forever the Shiva lingam.

Principal impulse of energy adorned by heat of desire, not acted upon by the warmth (of that desire), destroying the heat of that tumult, I know as the lingam that is forever the Shiva lingam

The entire dense dark greatly smeared by the power of forming and retaining thoughts causing to augment them accomplishing light and dark to be formed, I know that as the lingam that is forever the Shiva lingam

The great knowing adorned to produce easily motion bound greatly destroying the diffusion of energy, I know that as the lingam that is forever the Shiva lingam

As we saw previously, the Shiva Lingam is the space within the constriction created in the entanglement within which the first bend of the pure starts to occur and hence creates Shiva. A lot of the information in this Ashtakam agrees with the Shiva Tandava sthotram. Below, what a Lingam is below:

Figure 30: The Lingam in the Entanglement

This describes that the churn surrounds the Lingam, which is what we saw previously. We have taken an entanglement and created a constriction and that place of constriction is the Lingam. So surrounding the Lingam should be the entanglement or churn.

As we were told in the Shiva Tandava sthotram, when constricted, we have a pure place. Here also it says the same thing, except that it says it also is in equilibrium and pure. This has eased the orthogonal bend from the entanglement, thus causing the start of creation of that space which in-turn caused the creation of the environment. So, the Shiva Lingam has been the reason to instigate the birth of the environment.

We also know that we need the constriction to be subject to frigid conditions, which is also said here, destroying the heat of the tumult. Again, this is the space in which the environment is created. This says that this has the power to form and retain the environment in which thoughts are formed, which indicates that the Shiva created is the same as the environment we have been reading about previously where awareness is formed.

This is also the place where motion can be produced, because of energy created by the direct and reflected light. So, we find that we are correct in

the assumption that the Lingam is not really the orthogonal environment, but the space created when the entanglement was constricted.

But, more, what is important here is that such a structure has the power to support and form the Shiva that we were looking at. So, my take is that the constriction needs to be of a specific form and size, so that the Shiva formation can be triggered and sustained.

Kungkuma-Candana-Lepita-Linggam Pangkaja-Haara-Su-Shobhita-Linggam |
San.cita-Paapa-Vinaashana-Linggam Tat Prannamaami Sadaashiva-Linggam ||5||
Deva-Ganna-Aarcita-Sevita-Linggam Bhaavair-Bhaktibhir-Eva Ca Linggam |
Dinakara-Kotti-Prabhaakara-Linggam Tat Prannamaami Sadaashiva-Linggam ||6||
Asstta-Dalo-Parivessttita-Linggam Sarva-Samudbhava-Kaaranna-Linggam |
Asstta-Daridra-Vinaashita-Linggam Tat Prannamaami Sadaashiva-Linggam ||7||
Suraguru-Suravara-Puujita-Linggam Suravana-Pusspa-Sada-Aarcita-Linggam |
Paraatparam Paramaatmaka-Linggam Tat Prannamaami Sadaashiva-Linggam ||8||

Translation:

The reddish brown reflected light smeared as a garland in concentric circles adorning the lingam destroying the imperfection of density, I know as the lingam that is forever the Shiva lingam

Banded energy adorning the lingam is preserved becoming bonded into multiple creating light, the highest light creator, I know as the lingam that is forever the Shiva lingam

To get split from the enveloped lingam is the cause of all existence, to attain the destruction of deprivation is the lingam, I know as the lingam that is forever the Shiva lingam

Initiating the shining of dense space, shining thickset expanding adorning the remote henceforth personifying the lingam, I know as the lingam that is forever the Shiva lingam

We know that the reddish brown vibration is the one which can easily split and start forming the Shiva that we saw in the previous section. It has banded energy, is split from the entanglement and enveloped by the lingam. Thus we see Lingam as that space in which the Shiva is created.

Figure 31: Shiva in Lingam

Relating Modern Science to Reality as Defined

It is easy to read these verses and imagine what they are talking about. But it starts taking on a meaning only when we relate it back to the reality we live in. Irrespective of what we understand, it has to be recognized that there is a common perception of the reality around us. For e.g., newton's laws which says a body stays in inertia unless acted upon by an external force, or every action has an equal and opposite reaction is a common perception by all "awareness." Gravity is a common perception by all "awareness," whether we call the awareness as remote or "I." It needs to be explained. physics, chemistry, maths etc are real in this world and cannot be ignored.

We are studying the underlying environment and the knowledge of the environment. While we have been talking about awareness of the knowledge of the environment that has caused sentience, we have not talked about a specific knowledge. Modern science is all about very specific knowledge such as space, time, matter, components of matter, molecules, atoms and so on.

The first and foremost to contend, is the definitions of various concepts. Modern science tends to forget about the underlying causes for the existence of a concept and describe the concepts purely from the perspective of perception by the human body or matter. The definitions of the concepts are almost always relative to another equally fragile concept.

For e.g., definition of force. According to Wikipedia "In physics, a force is any interaction that, when unopposed, will change the motion of an object." It is relative to two objects. What is object is not defined. A set of assumptions are made, what is motion? What is change? Is force only related to matter? What if there is no matter? Is force present or not?

Another e.g., definition of gravity. According to google, "The force that attracts a body towards the centre of the earth, or towards any other physical body having mass." Again we see it is relative. It assumes the existence of mass and physical bodies and has not gone deeper than matter.

At best, our concept definitions lie on the periphery of the plane of reality with practically zero or no relation to the inner workings of this plane of reality we live in. But, this does not imply that the concepts themselves are not correct. Concepts like energy, space, force, gravity, centre of gravity, entropy and so on do exist, not because they are defined by human beings in human understandable language and description, but because they are a part and parcel of the underlying environment in which humans are formed. These concepts exist inherently and the knowledge exists in each and every living being in this world of knowing even if the terminologies and definitions are not shared in the same manner.

As we learn the various concepts in modern sciences we find we can split them into multiple buckets. Those, that "I" inherently know, for e.g., force, gravity, inertia and so on, those, that I can sense e.g., water, food, forms of nature, feel of the wind, sound of vehicle and so on, those, that I have trained myself to know for e.g., H_2O is water, NaCl is salt, Na is sodium, 2+3 is 5, newton's laws and so on, those, that I have experimented and known, this is something which varies from one person to another. There also exists emotional knowledge, social etiquette kind of knowledge and many such, which are just boundaries established to prevent the natural freedom of human life and a secondary level of unnecessary intelligence. All of them can be classified into a bucket called self-preservation. The first two buckets are knowledge, while the next two can be classified as intelligence i.e., a derived logic. The first two buckets are the concepts that every living being knows.

The first category of knowing is something so inherent, that even if you do not give a descriptive name to the concept, you know it. Gravity, centre of gravity, inertia and so on, though taught in curriculum, are concepts that are known by all of us and the dogs, the cats, the birds flying, the plants and every living being.

Irrespective of a dog, a stone or a human being, when thrown up, fall down due to gravity. The knowledge of gravity exists. Irrespective of a human, cat, rat or a stick the centre of gravity is always where all the

body's weight is in balance. Just because a stick does not describe centre of gravity, it does not mean it can stand at a slant defying the laws of knowledge of the environment or just because a cat cannot describe centre of gravity, it does not stand at an awkward position where there is no balance.

What is needed, is to redefine each of these concepts with the overlapping environments in mind and by understanding that the "knowing of knowledge of an environment" is basically a change detection in density. For e.g., as we saw, force is inbuilt in the detection mechanism of knowing the knowledge. As we saw, as awareness traverses the underlying environment, it experiences resistance preventing it's progress which automatically becomes force. Thus inherent to the mechanism force exists. Defining it external to this only adds unnecessary unknowns and variables into the definition, which when challenged can turn the whole science based on this concept, upside down.

In modern science, the primary concepts that drive most of the other concepts are space and time. We have read a lot of time and the illusionary aspects of it and the various perspectives in which time can be viewed. But, we have not talked about space.

Space has no standard definition in modern science. According to Wikipedia, "Space is the boundless three-dimensional extent in which objects and events have relative position and direction." There are a number of variables here. What are the dimensions of space. We can call them axis X, Y and Z. But each and every human will draw the X, Y and Z axes differently. It is three dimensional with reference to what? Relative position and direction. We seem to have arbitrarily assigned a set of orthogonal lines and plotted points in them and decided that is space. But, with such a vague definition of space we cannot move further. Yet, all of us know what space is.

This chapter is just an attempt to show how the underlying concepts can be redefined based on what we have been reading. Please note, the samples I have given here is an interpretation based on the study. It is a sample to indicate that having such a definition helps us move forward. In no way is it claimed to be correct or wrong. It is just claimed to be a possibility. I am just bringing out the problems in our current definition of science concepts.

SUMMARIZING THE CONCEPTS OF THE ENVIRONMENT

Now, that we have a glimpse of the environment, we can now start defining concepts based on this and see if it fits into what we understand of the environment. First to draw the environment as we understand it:

Figure 32: Top Level View of the Environment as we had Described in the Previous Chapters

As we saw, knowing the knowledge of the environment boils down to density distribution of direct and reflected waves. But, what we also need to co-relate is that "knowing the knowledge of the environment" is also a form of "knowledge of the environment." Just like the electrodes taking on positive or negative ions based on the solvent they are present in, we detect density change from our reference point based on the density distribution around us. The concentric spheres inherently detect density when having the knowledge of the environment and thus forms the second layer of awareness or knowing the knowledge of the environment.

How does this density change detection translate to description is what is defined as the various layers of knowledge as described by the Maha Kalabhairava sthotram.

DEFINING SPACE

Space is the whole environment in which all this reality is played out. So, **the whole pulsating Shiva can be considered to be space** in which the awareness is formed. It starts at the connecting point or where the Lingam base is and extends all the way till the circling back point of the wave which is the tip of this system.

Figure 33: Space and Environment

The minute we do this, the various problems in our definition of space starts standing out.

The first and primary is that given we had no shape given to space. Space was considered to be arbitrarily big. So, any arbitrary three axes could be drawn in any direction and they could be used to indicate a point in space. While this definition is good, we limit our understanding to things within this visible reality, it cannot be a universal definition for any and every point in space.

But, now that we have removed the infinity from the definition and we have given it a specific direction, with the forehead or the point of connection to the unmanifested as the point of origin, any arbitrary three axis cannot represent the point. A specific set of axis start getting defined. And maybe as how it is told in the sthotrams rather than 3 dimensional, we need to start having a 5-dimensional space. And no, gravity and time are not dimensions of space. Gravity possibly can be an indicator to one of the dimensions as we will see later on, but it is not the dimension.

DEFINITIONS OF DIRECTION

Directions are varied in modern science. There is a magnetic north and south, defined with reference to earth's magnetic field, there is a polar north and south, defined with respect to the sun. Now that the magnetic field of the earth is switching, the directions are also going for a toss. And so, as changes occur in the space around us, we find we are floating trying to correct for the external change.

In the space definition that we do with respect to the environment, we find that direction is a part of space definition. At any point in this space, if we are able to detect the pulsating wave and the direction, we should be able to use it to indicate direction at that point. Direction can then become relative to the head of the pulsation which is Lingam point.

Again, we should note, while all these are still defined as relative concepts, the difference is that the relation is to the actual cause of the existence of this environment. If this cause collapses, anyways all our concepts collapse and we need to define concepts based on what is formed after that.

FORCES AND INERTIA

As we saw previously, force is inherent to the system. Focussing to a specific area where the density detection occurs, we see that the awareness tries to influence the environment and the environment tries to influence awareness and both come to an equilibrium which then gets detected. That influence is force (From the previous figure)

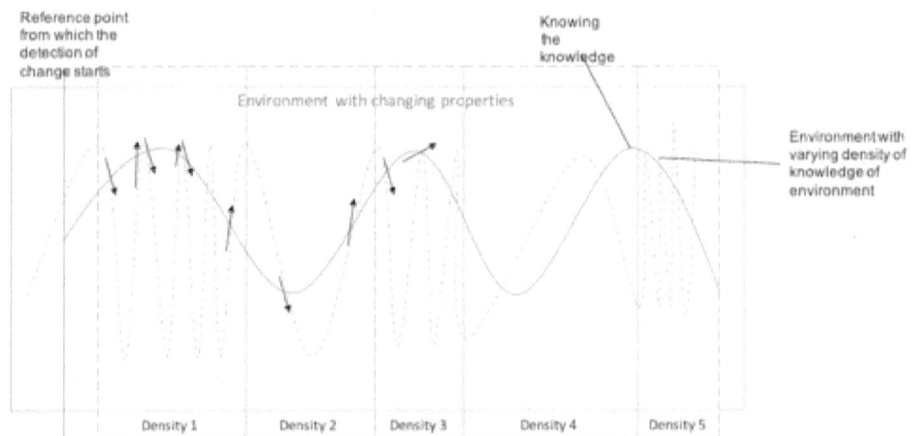

Figure 34: Force

With this definition of force, we start asking ourselves about Newton's law of equal and opposite force. What else is equilibrium? Obviously, nature comes to settle at a point where each has exerted the cancelling force against each other.

Inertia is where awareness cannot influence the density at that point in space anymore and some external awareness or reflected wave is needed to change the state of density at that point.

GRAVITY AND CENTRE OF GRAVITY

Gravity and centre of gravity are two concepts whose explanations are murky in the modern science. Gravity which is the pull of one object to another such as a human to the earth is also considered gravity and gravitational waves due to space-time curvature is also defined on the same concept. But, if we start thinking about it with respect to this environment that we have defined, it seems as if we need to split the two of them as two separate forces.

The attraction between two objects is separate and the global gravitation waves that was recently discovered is different. The recent gravitation waves that were discovered may relate to the pulsation in the environment that has a direction towards the base of the Lingam that connects to the entanglement, while the gravity as we know it, is purely the pull between two centres of concentric circles formed within the environment.

The curvature of space is also inherently present in this environment, basically because the waves circle back to the Lingam. All those that exist within this environment should obviously have an attraction or force towards the base of the Lingam for the wave to turn back in a circle. Which means anything formed within that environment obviously experiences the force of the base of the Lingam. This maybe a subtle force when compared to the pull of other concentric spheres around it, but still present.

See the diagram below.

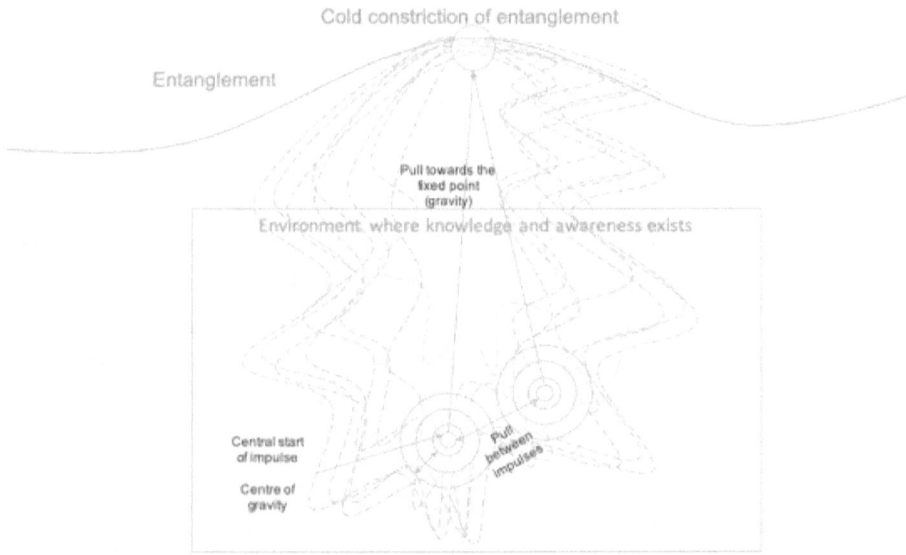

Figure 35: Gravity and Force between Objects

DISCLAIMER

This chapter is purely present to bring out the fact that we may have to rethink our modern definition of concepts with respect to something more reliable than the illusionary reference points that we currently use.

I have no idea if what is written in these works of literature are points that were proved at some point in time or not. I have only tried to translate them based on a certain reference which I thought they were written against. It is strange that all the literatures hold water and link together cohesively to form a thread of reasoning that can indicate the formation of Shiva. Proof of validity of such a science cannot be found with what we consider proof for modern science. When the science is as relative as what we have, nothing can coherently hold up.

My take is that proof of such a science can be got only if we can go the higher level than what we are at in this current plane. Again my take is that, that plane of observation can be reached had we not lost out on what meditation and yoga really meant. I believe even meditation and yoga have reduced down from their original scientific forms to meaningless chakras and aasanas.

For e.g., the Vrksasana, the tree pose or standing on one leg. It has been promoted to being purely to improve balance. This has to be tried with no sensory inputs at all. Eyes closed, ears closed and ignoring touch, and no references to the outside world, to understand. It helps you find your centre. Gravity is truly understood in this aasana. The sirasana is another such which helps you find the centre. It is necessary that you shift your centre of gravity to understand what centre of gravity really is, instead of reading a definition and memorizing it.

To understand the various layers of awareness, there is no other path other than to get your brain into a resting condition, recognize the difference between the top smoothed out layer of emotions, logic and other layers of the thought and separate them out from the underlying vibrations that are causing those reactions. How else to see these layers? What proof can be given for the existence of heat that triggers emotions?

Unless we cross these various layers of awareness, how can we see that underlying Shiva pulsation that is causing this environment and know it to be true or not? There cannot be a proof to the same brain that is actually fooling us into believing that these relative thoughts that we have are in actual reality.

A Path into the Unmanifested

From the Shiva Tandava sthotram we find there is an entanglement from which this universe is formed, within a Lingam that supports it. There is an orthogonal bend from the constriction that forms the Shiva and hence the vibrations of the environment.

The next question that arises then is what is that entanglement and how does the constriction arise to set free that single vibration to form the environment? The Vijnana Bhairava is a conversation between Bhairava which is unmanifested and Bhairavi which is the manifested. This must have some clues as to what the Bhairava is. So, we go study the verses in Vijnana Bhairava.

I should mention here, while the book is a research about Shiva, which is the environment (pulsation, vibration, reflection, lingam and all) and we can end it with the Shiva Tandava sthotram which shows the formation of Shiva, I have continued it a little further into the unmanifested. The research of that unmanifested and how that entanglement is formed and supported seems to be another involved research of the literatures.

Thus, this chapter is just a view into a still on-going research and hence is just a beginning for the next stage of the research, following the path into the unmanifested.

As an aside:

> *According to Wikipedia, Vijnana Bhairava tantra is a text of the Kashmir Shaivism and is a discourse between "God" Bhairava and his consort "Bhairavi." Further it is stated that the Vijnana Bhairava presents Tantric meditation methods or centring techniques.*

On the face of it, reading the text with the standard translations, it definitely seems as if it is a set of meditation techniques. As a matter of fact, a lot of the Sthotrams and Mantras translate into a whole lot of different versions of recognizable sentences that appear to be the true meaning of the sentence and can be easily twisted to mean what we want it to mean. Yet, if we go in-depth and start looking at the consistency or lucidity of the verses together, these meanings fall apart.

As I have indicated before, we cannot have pieces of spectacular intelligent information coupled with totally insane information with no continuity or relation between the verses. Either everything is un-meaningful or everything ties together with a thread that we do not understand. I for one do not think a set of verses would last so long (supposed to have been written in the 800 BCE to 500 BCE) without having a very good essence to it.

SEARCHING FOR CLUES

Let's take the translation of "Bhairava," it has a whole range of meanings starting with it being "a name of a God" going to being a "terrible form" to "formidable form" based on where it is used. Now, if Vijnana truly meant knowledge, then associating that with a word which stands for formidable or terrible makes no sense. We could possibly translate it to "formidable knowledge," but again when we look at the translation of the contents of the book, the knowledge does not seem to be so formidable? Especially, given that if truly it was just meditation techniques, there are only two lines of each meditation technique and gives no information of how to meditate. It should have been named something related to summary then? So, I find the name and the contents do not match or the name and contents have been translated wrong.

Translating Chandogya Upanishad's Sanatakumar's dialogue with Narada, Vijnanam seems to have a totally different meaning. The sequence in which SanatKumar goes is:

nama → vagvat → mano → sankalp → Cit → Dhyanam → vijnanam → balam → annam → apo → tejas → akaso → smaro → asa → Prana

Ancient Philosophy ♦ 99

In this we are looking at a sequence where it flows from name to description to manas to direction to awareness to focus to vijnanam. Now here, vijnanam cannot be intelligence, because "intelligence" can only come after manas because of which we have brains. That which comes after vijnanam is balam which is force. Hence Vijnanam has to be "coherence" of the various forces to get a focused direction.

If Vijnanam means "coherence," then Bhairava cannot be a God nor formidable. We cannot have a coherent God nor a formidable coherence? Hence it follows that the Bhairava translation that we have is not correct.

We can read into the Vijnana Bhairava to find the answers to what Bhairava really is. The Vijnana Bhairava can be split distinctly into three pieces. Bharavi questioning the Bhairava about the Bhairava. Bhairava answering the questions and subsequently explaining "What Bhairava is" to Bhairavi. The most illuminating in the questions is with regard to Bhairava is this:

Kim va navatmabhedena bhairave bhairavakrtau
Trisirobhedabhinnam va kim va saktitrayatmakam |3|

Without translating Bhairava and Bhairavi we get:

How does a new self-divergence of the Bhairava, become Bhairavi? How does this three-point divergent split become a self, consisting of three characteristics?

This question by itself clearly defines what we have been seeing from the Shiva Tandava sthotram. The entanglement splits with one being orthogonal to the other and in the orthogonal piece we have Shiva which is the environment that sustains reality.

Even in the above translation indicates that "Bhairava" becomes "Bhairavi" and is self-divergent which is what we saw. It also indicates that it has three dimensions, again something that we saw of the awareness in the environment.

Thus "Bhairavi" is "that which has become" or simply "manifested" reality around us and Bhairava should be the entanglement, or that which has not yet manifested or simply the "unmanifested."

With this the title becomes "Coherent Unmanifested." This now indicates a very interesting concept. The unmanifested need not be coherent, which fits well with the entanglement that we have been talking about.

The next interesting part of this work comes in the answers given by the Bhairava to Bhairavi's question:

> tadvapustattvatho jnayam vimalam visvapurNam
> evam vidhe pare tattve kah pUjyah kaShrva trpyati

Translation:

The cause of that formless concept is beyond this universe completely, hence to know this concept who can be worshipped or what can be heard or pacified.

This matches exactly what we had seen before with the formation of the environment. The environment that got created is totally orthogonal to the entanglement and the entanglement from which it has been created is formless and totally beyond this environment in which reality is present.

How can we then worship the, who and what that exists only in this environment, to understand the other unmanifested dimensions? This is like drawing on a paper a 3D drawing which still exists in 2D and expecting a 3D model to emerge from it? While the illusion of 3D can be created, it is still, only a 2D drawing.

> evam vidha bhairavasya yaavastha pariglyathe
> saa parA pararUpeNa parA devi prakirtitaa

Translation:

Hence, what can be declared as the state of unmanifested, it is said to be beyond form and existence and manifestation

This is even more enlightening. This brings to fore the fact that we do not even know the questions that can be asked of the dimensions of the unmanifested. The instant we call it a "state" and ask "what is the state of

the unmanifested," we already have talked about the manifested. So, the question by itself is a wrong question!

> shaktishaktimatoyadvad abhedah sarvadA sthitah
> atastaddhrmadharmitvaat parAshaktih parAtmanah
> na vahnerdaahika shaktivryatirikttaa vibhavyate
> kevalam jnaanasattaayaam praarmbhoyam praveshne

Translation:

As how energy and possessing energy is indivisible similarly, action and driver of that action are indivisible and beyond existence of energy and self
As how, without burning, we cannot clearly perceive that energy is different (from possessor of), by merely seated in knowledge one cannot begin to know this (unmanifested)

The problem of *"understanding"* the unmanifested is got out here very clearly. If I take a piece of dry wood, I have no clue whether it will burn or not. The heat has not separated out from the wood part of it, it is just a piece of wood. To know that the heat energy is actually present, I need to burn it, in which case the wood is lost. Similarly, in this environment I am in, to know there is an unmanifested, I need to have a manifested possibility, but then it has already manifested, how can I know then?

From all these questions and answers tell us that we are on the right path and finding more about Bhairava should give us more glimpses beyond this environment.

FROM THE UNMANIFESTED TO THE MANIFESTED

The first glimpse of how Shiva could possibly start forming comes from the translation of the below verses of Vijnana Bhairava. In the standard translations, these are the set of verses that are claimed to be indicating ways to meditate to understand God. But, in my view the actual translation point to something completely different. The question which we need to ask ourselves is why would a text that started out as Bhairavi asking Bhairava the question of "What is Bhairava?" provide an answer to any other question other than answering that core question that is asked? The answer obviously should be "no, it does not." The verses are still

answering the core question of what is Bhairava. It is our interpretation of the verses that is wrong and we need to relook at it to find out what is the actual meaning. You can look at my blog at (https://ancientinsight.online/2018/04/28/vijnana-bhairava-on-manifestin-of-the-unmanifested/) to understand how I have translated these verses as below:

> Urdhve praNo hy adho jivo visargatma paroccaret
> Utpattidvitayasthane bharaNAdbharita sthitiha ||24||
> maruthontarbahirvApi viyadyugmAnivartanAt
> bhairavyA bhairavasyettham bhairavi vyajyate vapuh ||25||
> na vrajenna vishecchatkirmarudrupa vikasite
> nirvikalpatayA madhye tayA bhairavarUpatA ||26||
> kumbhitA rechitA vApi pUritA vA yadA bhaveth
> tadante shAntanAmAsau shaktya shAntah prakAshate ||27||
> AmUlAtkiraNAbhAsAm sUkshmAth sUkshmatarAtmikAm
> cintayettAm dviSTkAnte shyAmyantIm bhairavodayah ||28||
> ugdacCantIm tadidrUpAm praticakram kramAtkramam
> UrdhvAm mushTitrayam yAvath tAvadante mahodayam ||29||
> kramadvadashakam samyag dvAdashAkSharbheditam
> sthUlasUkshmaparasthityA muktvA mukttavAntatah shivah ||30||

Translation:

The prana arises to create duality or happening and non-happening, this oscillates between fading and becoming clear till the restraint that is preventing the formation is scattered. In the midst of non-imagination this restraint is scattered and the unmanifested begins it journey of being formed. Here, the existing equilibrium has to be broken and a second equilibrium with this manifestation needs to be defined. Even then the inertia of the existing equilibrium in the form of aversion has to be ended then the first rays of the thought arises. Once arisen it is partial and is augmented circle on circle like a progression till from that subtle thought it has become dense thought aligning the twelve centres to form imperishable distinctions, setting free the remote, this then is Shiva.

What is important to note in this translation is that it is describing a series of steps starting from Prana till Shiva starts forming. The Shiva Tandava sthotram describes how the external or the orthogonal piece is

formed to create the direct and reflected light environment where impulse and further awareness can be formed, this section of Vijnana Bhairava describes the prior series to the formation of Shiva. How the unmanifested starts becoming manifested.

According to this "Prana" is the starting point. Since we are looking at all of these as potential to exist or not, an environment of all possibilities, rising of Prana has to be that something triggered one possibility to take on a probability of "1." This should cause all other possibilities to go to a probability of "0" thus creating the dual state that is being talked about here.

Now, according to this there is a restraint that is preventing it from staying at a probability of "1." So, it oscillates in this state of "1" and "0" till that which is restraining goes away. What this restraint is, is not said, but it does say that in the midst of nirvikalpa this restraint is scattered. I have translated nirvikalpa as non-imagination, but I have my doubts here. We are in an environment where even the idea of imagination as we know it does not exist, then why should non-imagination even play a role? No, I have no clue what it could be, but nirvikalpa it is that scatters the restraint which makes Prana oscillate between the two states.

This triggers the unmanifested to go towards manifestation. So, there existed an equilibrium before it starting manifesting where all possibilities had equal probability, now one possibility has started having a higher probability, so by infinite recursion that occurs, another equilibrium has to start getting established before anything can happen.

Once, that gets established, my take is, then we are looking at the wave becoming orthogonal and starting to build the pulsation that we had in the environment. According to this verse, there needs to build 12 centres of pulsation all aligning with each other, thus forming Shiva and the environment where remote exists. What is Prana, Nirvikalpa, the restraint etc is anyone's guess. A more in-depth research on all these topics are needed to get more information here. But information on this is very hard to get even in these works of literature.

THE SCIENCE OF YIELDING

The Sri Rudram is a part of the Taitarriya Samhita and pure translation translates it to "mix of turbulence." While the Shiva Tandava describes the formation of the environment, the Vijnana Bhairava describes

how the Bhairava become the Bhairavi, the Sri Rudram describes the interaction of Isha, OM and Rudra which is prior to the entanglement from which Shiva emerges. Simply put, it could just be a description of the formation of that entanglement.

I have called it the science of yielding because prior to the formation of environment, it seems like, it is what yields how much to what that determines what happens. The Sri Rudram is a series of yielding of one to the other that forms something else. My take is this is not exactly a complete submission but the process of establishing equilibrium as we saw in infinite recursion, where one exerts an influence on the other and vice-versa before finally settling into an equilibrium. What exerts how much influence on the other determines who yields to who.

What needs to be thought about here is that yielding can only occur when we talk about force. When we do not have force even playing a part at this stage, how can we talk about yielding? Hence, my choice of words is influence instead of force.

om namo bhagavate rudrāya | |
om namaste rudra manyava utotA iShave namah |
namaste astu dhanvane bāhubhyāmuta te namah |
yā ta iShuh śivatamā śivaM babhūva te dhanuh |
śivā śaravyA yā tava tayā no rudra mruDaya |

Translation:

OM yields to this glorious turbulence. OM by yielding has weaved the manas of turbulence by turning away from this environment of all possibilities. By yielding this existence acquires a flow by suppressing many that yields from weave. Those that of the environment of all possibilities the shivam of shiva have become that island, shiva targets those that are moving in that turbulence, unrestricted.

Here it should be noted that this verse does not talk about how OM is present or turbulence is present. It has assumed that there is OM and there is turbulence in that tranquillity. The next important concept to note here is the term "weaving." To be noted, it is not formation or creation or anything related to being newly instantiated. That which is existing is weaved into a pattern to form something.

Figure 36: OM Yielding to Turbulence

Another concept to note here is that not everything that is yielding goes on to become the next. Only a part of what is yielded goes on to get into the weave. Thus we see emerging before us a turbulent form choosing some, letting go of some, based on whatever logic that it has and this is called the "rudra manas" or the "the knowledge of rudra to choose." This then goes on to form Shiva as we saw in the previous chapters.

<div style="text-align: center;">

yā te rudra śivā tanūraghorā'pāpakāśinī |
tayā nastanuvā śantamayā giriśaMtābhicākaśīhi |
yāmiShuM giriśaMta haste bibharShyastave |
śivāM giritra tāM kuru mā higMsih puruShaM jagat |
śivena vacasā tvā giriśācchāvadāmasi |

</div>

Translation:

That which remains imperfect after the turbulent shiva is stretched, that which is not settled from the turbulence in the end manifests. That illusion when mixed with turbulence and a handful settles with shivaM protecting the turbulence, that collected form, sets in motion this earth, the world of "I"s, then, that which shiva dictates into that turbulence, in there that is described.

Now, we can start relating to what is being referred here. Shiva is stretched implies where the waves turn orthogonally at the constriction and extend till it turns back to create. Thus Shiva is stretched. Here it claims that, even though not all that yield are weaved, if OM reacting to the turbulence does not settle, it goes into Shiva and manifests.

Now, the strange part of this verse is, it claims that the turbulence is being protected by the Shivam, which is the constriction. That is why Shiva Tandava sthotram said "Tanotu Nah Shivah Shivam" or "stretching becomes Shiva of Shivam." This can only mean that the constriction from where it is stretching is "Shivam." So, Shivam and Lingam are the same.

This seems to imply that by "constricting" whatever that means, turbulence is created which has made OM yield to this turbulence and thus causing the whole trigger of creation of Shiva. Subsequently, the constriction is also ensuring that presence of turbulence to ensure a continuous maintaining of the Shiva pulsation formed.

Yatha nah sarvamijjagadayakshmag sumana asatthu ||
Adyavochadadhivakta prathamo daivyo bhisak |
Ahlgsrava sarvanjnaambhyayantsarvasrva yatudhanyah ||
Asau yastamro aruna uta babhru sumangalah |
Ye chemam Rudra abhito dikshu shritaha Sahasra sho vaisagum heda imahe ||

Translation:

In this way not all submerged in description is consumed by illusion of manas, the description of now gives a description of that which is the same as the original. The entire sound turned in all directions is engulfed limiting all sounds to that which is granular in that settled, a particular light-brown weaves into a favourable deep brown, those that drink turbulence approaching initiation having undergone many changes, encompassed in these.

I will not even claim to understand this. I am sure, I must have got some of the translations wrong here. For eg., illusion, manas and description are more part of the Shiva environment. So, why are they mentioned here I wonder.

The only thing that I understand here is that the light brown and the deep brown are the vibrations favoured by the formation of Shiva, which

is what we had gathered from the Shiva Tandava sthotram also. But, this verse is definitely describing how the limitations are set to ensure that the appropriate vibrations are pushed toward formation of Shiva.

Further down, I have just left the verses with just the translations. Again to re-iterate this part of the unmanifested is an on-going research and will be a part of the next research book, when I understand this.

> Asau yo vasarpati nilagrivo vilohitah
> utainam gopa adrushanna drushannu daharyah
> Utainam vishva bhUtani sa drusto mridayati nah
> Namo astu nilagrivaya sahasraksha midhushe
> Atho you asya sattvano ham tebhyo karan namah
> Pramuncha dhanvanastva mubhayorartni yorjyam
> yascha te hasta isavah para ta bhagavo vapa

Translation:

In that which is emerging master of the dark constricted, deep-red, woven, this guard of that which is seen and also that which is not seen is quenched, woven this all has become, is not restricted to that which is seen. Submitting to this reality in that dark-constricted, many axis infinity, thus this weaving established in that, they cause surrender, turning towards a steady spot, obstructed at both ends, that which resonates with this handful of potential remote, it successfully weaves.

> Avatatya dhanustvam sahasraksha shatesudhe |
> Nishirya shalyanam mukha shivo nah sumana bhava ||
> Vijyam dhanuh kapardino vishalyo banavam uta |
> AneshanneShava abhurasya nishangathihi ||
> Ya te hetirmidhustama haste babhuva te dhanuh |
> TayAsman visvatastva mayakshmaya Paribbhuja ||

Translation:

That extended by a certain length covers many axis and many potentials correspondingly, with no perishable point of direction, an acceptable direction is not got for shiva, then a non-focussed set is weaved, many fallen, established potentials, a void condition is established.

> Namasteastu bhavagan vishvesvaraya mahadevaya
> triyambakaya triupurantakaya trikalagni kalaya kalaagni
> Rudraya nilakanthaya mrutyunjayaya sarveshvaraya sadashivaya
> Sriman mahadevaya Namah

Translation:

Yielding to seeking that illustrious reality from that all potentials causing the primary energy pervading all three worlds, freeing the three similarities, causing the three indistinct heats of time, the heat of time causing turbulence that causing dark constrictions gaining the perishable of all potential always the shiva, surrendering to the mix of prime energy.

DISTINGUISHING BETWEEN ISHA, RUDRA AND SHIVA

I would like to end this book with a summary picture of what we have translated from the works of literature. From all that we have seen described in the previous chapters, the following diagram summarizes what Isha, Rudra and Shiva are.

Figure 37: Isha, Rudra and Shiva

Isha is the tranquil all potential that is ever present and omniscience. Mostly, this is what is covered with OM, because it is said that OM yields to the turbulence. The Isha Upanishad says:

> isavasyamidam sarvam yatkincya jagatyam jagat
> tena tyaktena bhunjitha ma grdhah kasyasviddhanam ||1||

Translation:

This entire world that is moving is covered by potential, hence give up this inquiry who has set in motion my experience of desires

Rudra is the turbulence that is caused in this tranquil Isha, that weaves the OM so that it can bend to form the Shiva and the constriction or Lingam protects the turbulence from fading away. The Sri Rudram says:

> om namo bhagavate rudrāya ||
> om namaste rudra manyava utotA iShave namah |

Translation:

OM yields to this glorious turbulence. OM by yielding has weaved the manas of turbulence by turning away from this environment of all possibilities.

Shiva is that environment that is created out of the waves that have yielded to the turbulence and turned away from being just possibilities.

THE END

Om Bhadram Karnnebhih Shrnnuyaama Devaah | Bhadram Pashyema-Akssabhir-Yajatraah |
Sthirair-Anggais-Tussttuvaamsas-Tanuubhih | Vyashema Deva-Hitam Yad-Aayuh |
Svasti Na Indro Vrddha-Shravaah | Svasti Nah Puussaa Vishva-Vedaah |
Svasti Nas-Taarkssyo Arisstta-Nemih | Svasti No Vrhaspatir-Dadhaatu ||
Om Shaantih Shaantih Shaantih ||

Let OM safely reveal the free energy, safely perceiving the magnificent knowledge,

with steady calm mind lessening description, absorb the appropriate energy that is generated

Let not the senses destroy entirely what is heard nor the worldly knowledge increase immensely

Let us be fully protected, safely encompassed from earnestly thinking about creation

Let OM be silent, silent, silent

I hoped you felt challenged while reading this book and feel that there is a lot more hiding in the ancient works of literatures, not just superstitions and descriptions of worshipping Gods. If you liked what you have read in this research, please do leave a short review. It takes a minute and your review helps future readers and the author.

To get more details about the translations and how I arrived at these conclusions from the various sthotrams, Ashtakams and Vijnana Bhairava, you can read an word to word translation at my website: https://ancientinsight.online. While you are there, do follow my blog and I will keep writing more blogs with more translations and announce when I write more research books.

If you want to have more discussion on any of the topics that I have written in this book, do go ahead and write me an email at ancientinsight1@gmail.com.

www.ingramcontent.com/pod-product-compliance
Lightning Source LLC
Chambersburg PA
CBHW020924180526
45163CB00007B/2869